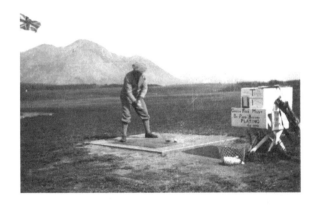

GOLF

IS

RUINING

MY

LIFE

Lechery, Anarchy, Delirium, Bourgeois
Inertia, Flagrant Hypocrisy, Primitive
Injustice, An Organized Crime in Fact

An Episodic Meditation

Brooks Roddan

Cover and interior design:
Ingalls Design, San Francisco

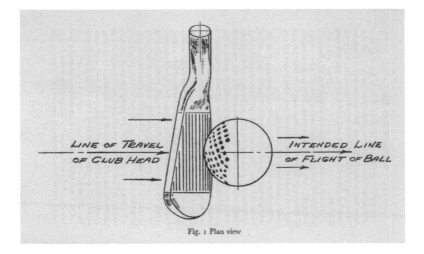

LINE OF TRAVEL
OF CLUB HEAD

INTENDED LINE
OF FLIGHT OF BALL

Fig. 1 Plan view

To my dear brother who played golf once and never played it again.

*However heartbreaking it may appear, contemporary life preserves itself
in its old atmosphere of lechery, anarchy, disorder, delirium, dissoluteness,
bourgeois inertia, psychic anomaly, deliberate dishonesty, flagrant hypocrisy,
sordid contempt of everything which shows distinction, laying claim to a
whole order founded on the fulfillment of primitive injustice—an order of
organized crime, in fact.*

ANTONIN ARTAUD
(1896-1948)

To my golfing friends and family.

This is a work of biographical fiction, utter fantasy, and digression. Be assured that none of you, those with whom I've played golf over the years and who've become, in many cases my friends, appear in this work as either real or fictional characters. If by chance you come to believe you recognize yourself in this book, please understand it is only me, the writer, you recognize.

This book does not have a plot, as a plot requires the kind of surveillance I wouldn't wish to impose upon anyone.

*At the very end of the book there is a bibliography of influencers and specific works that follows the flow of text at the back of the book that will greatly enrich the intelligent readers experience.

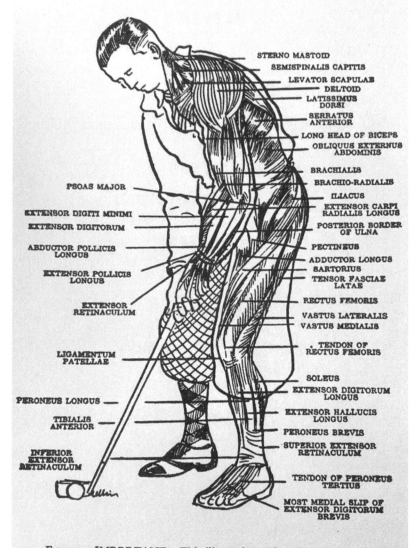

STERNO MASTOID
SEMISPINALIS CAPITIS
LEVATOR SCAPULAE
DELTOID
LATISSIMUS DORSI
SERRATUS ANTERIOR
LONG HEAD OF BICEPS
OBLIQUUS EXTERNUS ABDOMINIS
BRACHIALIS
BRACHIO-RADIALIS
ILIACUS
EXTENSOR CARPI RADIALIS LONGUS
POSTERIOR BORDER OF ULNA
PECTINEUS
ADDUCTOR LONGUS
SARTORIUS
TENSOR FASCIAE LATAE
RECTUS FEMORIS
VASTUS LATERALIS
VASTUS MEDIALIS
TENDON OF RECTUS FEMORIS
SOLEUS
EXTENSOR DIGITORUM LONGUS
EXTENSOR HALLUCIS LONGUS
PERONEUS BREVIS
SUPERIOR EXTENSOR RETINACULUM
TENDON OF PERONEUS TERTIUS
MOST MEDIAL SLIP OF EXTENSOR DIGITORUM BREVIS

PSOAS MAJOR
EXTENSOR DIGITI MINIMI
EXTENSOR DIGITORUM
ABDUCTOR POLLICIS LONGUS
EXTENSOR POLLICIS LONGUS
EXTENSOR RETINACULUM
LIGAMENTUM PATELLAE
PERONEUS LONGUS
TIBIALIS ANTERIOR
INFERIOR EXTENSOR RETINACULUM

FIG. 15.—IMPORTANT: This illustration, taken from p. 472 of Weil's *Primer of Putting*, should not be shown to opponent until the third week.

my left ear is right handed

In my left ear I hear my heart beating. It's warning me I must aim left-of-center, wherever center is, my good ear being somewhere right of it. I close my right eye as I've seen others on the golf course do when putting, hoping to read the green more clearly, holding their putters up to the imaginary line between their ball and the hole, measuring slope and distance as if they were master builders, looking out of their left eye if right handed or right eye if left handed, in either case believing they can predict the ball will roll either right or left as predetermined by gravity, and that they're better off playing golf with one eye open, not two.

It's just after 2 a.m, the best of time mixed with the worst. I'd only drank a little scotch earlier, a little more than yesterday perhaps, though not as much as tomorrow. I've written **Stay in the Present** in black ink on the wrong side of my left wrist, having also meant to write *drunk* instead of *drank* in the previous sentence. I'll erase my wrist in the morning—I'm almost certain writing anything on one's body is a violation of the rules of golf.

I'm playing golf tomorrow, or am I playing the day after? I believe I'm playing tomorrow, I've written it down somewhere. I look forward to golfing now in a backward sort of way, of having a good time even when it's not a good time—all too often these days—and before golf becomes everything that's happened in the past. A little more scotch won't hurt, another dram or two is what the situation calls for.

Jack doesn't understand. He calls the epigraph Artaud provided, '*the invocation*', thinking that's the correct word.

And who is Jack?

Jack's a man I met on the golf course some years ago who's become my sidekick *pro tem*, though his name isn't really Jack, he only calls himself Jack, an homage to a famous golfer who really is named *Jack*.

I explain to Jack that the epigraph was chosen for its clarity, in the hope of creating a large enough canvas on which to paint almost any

Jack___, confidant of narrator and ardent golfer

sort of picture; a piece of inspired language that reflects the critical thinking of an intelligent man and is therefore indispensable to the telling of the much greater story of how golf has ruined so many lives, his life, my life, and the lives of thousands, perhaps, millions of golfers.

Knowing how Jack thinks, having played golf with him for some time now, I know he thinks the epigram will overwhelm my story.

Jack believes the goal of being misunderstood was with me from the beginning, that I play golf because I enjoy being misunderstood, that when I say '**Golf is ruining my life**' it's actually a confession of my love of the game. Jack's semi-correct in a perjorative sort of way—golf is a form of confession, a mutant form of a prehistoric ritual—though he enjoys playing golf for money, a major error in judgment for an amateur. I don't play golf for money, as I don't write for money, doing a thing for money takes all the imaginary fun out of it, and I only ever wanted to make enough money so that I didn't ever have to make any more.

That I wasn't meant to understand, or to be understood, is my situation, I say to Jack—that my golf will be better if I do this or that differently or don't do this or that, *change my way of thinking, be positive if negative or at the very least realistic*, and so forth.

It's critical at this point, I say to Jack, **that I come to terms with my misunderstandings**. That I'm a good golfer one day and bad the next, that what once came easily now comes not at all or comes in a sequence that changes in the midst of my golf swing, then vanishes completely. Not that vanishing's a bad thing from time to time so long it's done to my satisfaction so that I don't vanish completely, that I can still feel my knees, whether they're the old knees or the new

knees, rotating properly to provide the necessary torque, and that the hips comply with the knees for a smooth transition.

Jack appears to be listening so I continue:

How often I have no ideas, I say to Jack, not one, and if there was to be one, a real idea that is, it would be ruined from the beginning. *The beginning itself is flawed, rarely if ever the sendoff that's expected.* From such a beginning nothing good can happen, only the futility of the present and the future, the past already having had its say. Then suddenly my golf ball lies down in soggy green pastures and I can't help but wonder, **Is this what the wind will make of me today?**

The usual answer being no answer at all, I say to Jack, *the question itself is aborted.*

Then on the very next hole another pushback from the old out-of-bounds. The cigar smoke of my companions, facing great difficulties themselves, wafts aimlessly amid the realities of unmet expectations: one is ten yards short, one is much too long, the other I've lost track of, finally spotting him behind a large eucalyptus tree.

The wind plays a greater roll in golf than we'll ever know, Jack says. *The wind's behind so many things.* I don't mind the wind when I'm indoors—I can listen to the wind for days if barricaded behind some enclosure—but to be out in the wind is a whole other matter, especially cold wind and its counterpart, hot wind.

I don't know which is worse, Jack says, *my description of the wind or the wind itself, hot, cold or otherwise.*

I've pissed in the wind too, Jack says, I'm proud to finally admit it, *I love to piss in the wind, it's one of the last great freedoms that belongs to a man,* to witness one's effluvia turn around in mid-air and change direction. I don't know a man who wouldn't rather go outside in what we call, for some reason, **Nature**, than in a tiled bathroom flooded with fluorescent light, Jack says, speaking as if he enjoys listening to himself speak.

Wind's a real factor, the wind will be the end of the world, wind will wear everything down, even the Great Wall of China, Jack says. The end of the world won't be climate change or the extraction of fossil fuels or the petrochemicals used on golf courses. **Wind will be the end of the world**.

Wind or no wind I'm convinced I must have a target, I say to Jack, changing the subject slightly, *the target is essential*, that I must point the crosshairs of the golf club at the target first and then aim, and not aim after the shot is issued and the lawyer summoned. The ball itself is much too small—a wee hardbitten little circle composed of synthetic plastic materials is all, as still as still can be—and the target difficult to ascertain, much less to consistently approach, surrounded as it is by failure after failure, some shots coming close, some better than others and many much worse, a sporting event not unlike the shooting of clay ducks without a rifle.

Golfing, I say to Jack, *I try to think ahead of time while at the same time acknowledging the wind as a feeling*, the wind having something to do with time that I'll never understand, often changing direction the moment the ball's up in the air.

The speed of wind is caused by the difference in temperature between onshore and offshore air masses, according to Jack. *Scientist's would have us believe the recent warming of the Arctic has reduced the temperature between it and the Equator, weakening the winds between them, making the wind an even more unpredictable force.*

True or not, I say, *not thinking ahead of time I get farther and farther away from the target whether there's wind or no wind*, at which time it's too late to consider what's to be

avoided, the torrent of trees on the right or the tall grasses on the left.

Episode 9

The wind gnaws away at things, Jack says. Which is why we get sick and tired of competition at some point—competition wears us out like the wind. *The wind likes to get ahead of time too*, Jack says.

Episode 10

Thinking ahead of time I often become stymied, I say to Jack, behind a tree or in a depression not of my own making or some other place where I shouldn't be. And there I am, having caught up with my golf ball at last, inseperably at one with the shot I've just taken. I don't know how I came to be where I am, whether there was wind or no wind involved, and so I have no other choice but to accept the present without living in the past.

Episode 11

Jack, who claims he's studied the ancients, including Pliny the Elder, says, *I'm just beginning to understand the source of your seemingly endless fount of feeling misunderstood, (it's classic Heraclitus, what I call The Divine Corollary)* **You can't step in the same river twice**, for it's impossible to do so, just as you weren't meant to be understood.

Jack insists I study the history of golf, that when I know golf's glorious past I'll become a better player, in a much better position to understand what I'm not now understanding.

Then he dumps a sackful of golf books on the front step of my home without ringing the doorbell.

I called Jack this morning.

I already have too many books, Jack, I say. **No more books** are to be allowed into my house.

But Jack insists I keep the small library he's lent me for the time being and that he won't take *'no'* for an answer.

The thing to know about Jack is that he has a very, very good golf swing. His swing goes on for miles and miles, creating beautiful landscapes both small and grand on which elegant farmhouses were built in previous centuries. The grand old houses look so lovely and graceful from a distance, with high windows and large front porches, and there's always a small private road leading to each of them. But it's far better to pass by them, to keep going, as beautiful as these scenes

may be. You never know what might be happening inside these houses, and usually what's happening inside is not as pretty as their outside appearances might suggest.

I plummet into golf's past as disclosed in the books Jack's bequeathed me, discovering that the history of golf roughly follows **the party line of imperialism: some people shouldn't have children, and the people who shouldn't have children shouldn't have been born**. Having been born, the people who shouldn't have had children reserve the right to form a coalition of like-minded people to create a club that promises to help pull its members up out of sandtraps so they can become more like the people who should have been born. The sandtraps are controlled by people who should have children and should have been born—*born leaders*—the directors of the club that the people who shouldn't have been born and shouldn't have had children must obey should they be fortunate enough to be admitted to the club.

I quickly lose interest in the books Jack's loaned me— there's too much history in the history of golf—and create a self-induced summary of my own, in imitation of a actual historian: **Golf's past is as mysterious as the wind**, but with a pernicious twist or two: that the people in control of the club are the same people who say that every life is sacred and yet are in favor of overturning laws that give women the choice of giving birth or not giving birth.

*" Golf's past is
as mysterious
as the wind,
but with a
pernicious twist
or two "*

On the golf course, I say to Jack after returning the books he's lent me, *I often find I'm talking with men to whom I don't know what to say and who don't know what to say to me.* We either have no discourse or we're on the golf course to escape discourse altogether.

I've noticed too, I say to Jack, *that those in positions of power at the club often speak in a kind of stage whisper, probably* to insure they maintain the privilege of enacting laws favorable to their power, and those nearer the bottom are convinced that the club is made of money first and civil rights second, but are members of the club anyway because they love to play golf.

Golf, I say to Jack on a day we're not playing, *is a semi-private club of like-minded people* permitted to talk confidentially amongst themselves within the confines of the club. The Directors, those at the top, believe they have a *vision* that will make the club even better and, once elected, either vote to amend the by-laws so that their vision becomes law, or vote to abolish the laws they don't like so that the laws reflect their vision. *We should never be happy with the law,* I say to Jack, especially laws that smell like what's stuck to the bottom of our shoes. We need to be especially wary of the big phony running for Club President, a guy named Todd, who says, among other things, *Our club is the last bastion of free speech,* as if it's a place where

a person can say anything he or she wants to say without worrying if it's the right or wrong thing to have said, not thinking at all about who's listening.

Pretty soon, Jack says to me, y*ou'll come to the place where you won't believe in anything.* You're headed down that road you know, Jack says. If you don't believe in golf what do you believe in? *True, golf's only a game*, Jack says, using the word 'only' in an exaggerated tone of voice, emphasizing the word 'ONLY', enlarging the word for dramatic purpose.

The problem with our way of life, I say to Jack, *is that it's now being controlled by people who constantly need our attention,* so that any and all oversight of the system is now a megalomanical exercise. I don't mean only golf, I mean the direction we've taken, the conditions we're making for ourselves in which golf plays a part. *It's so much worse than we think*, I say to Jack, we're losing everything we once we believed we had!

And we only know a tiny fraction of what's actually happening, we're only told a little bit here and there, slivers of truth whether true or not. *It's well known to historians and other so-called elites that truth is the only thing we'll have to live with in the end,* I say to Jack. But we don't want truth, truth's the last thing we want, we prefer lies, we suck down disinformation like it's Key Lime Pie. We can't fathom the whole picture, if anyone really knew the whole picture *what's called the whole picture would be classified top*

secret by people we've never heard of, who don't even hold elected office. Then, only after a period of time when we've all forgotten what we thought we knew, a time deemed safe by the experts, the facts will be released to us in little soundbites like some sort of public service. *In the meantime other crimes are being committed and kept secret so that the whole charade perpetuates itself,* I say to Jack.

Well, we might as well play golf, Jack says, *Golf's kind of fun* in a wholesome, fresh air kind of way. You come to believe you're actually doing something good for yourself, getting some exercise while smoking a cigar and listening to stale jokes, *socializing with your golf buddies,* Jack says, *feigning interest in what your buddy has to say.*

Where did the word buddy come from? I say to Jack. Buddy, what's a buddy? He's my buddy, or we're buddies, or worse, my buddy Tom and so forth when the Tom referred to is not around, is there only in the third person, an abstract buddy. **Such a demeaning word, buddy.** The word must be American, it sounds so much like the USA, *my buddy this, my buddy that, conjuring a flock of buddies,* many buddies, far-flung buddies in other cities and states, a wide, diverse range of buddies. The world's populated by people we either never see or see once and never see again, but still we insist on using the word, *buddy! Only men are buddies,* I say, women are too civilized to be buddies, not even women golfers have buddies, though professional women golfers might have buddies, it's possible, they're quite a different breed,

31

a specialized type of golfer, they stick together, they seem to be proud of that, of sticking together, I say. **It's possible professional women golfers have buddies**, *unlikely but possible.* I haven't seen or heard a great deal of professional women's golf but I bet I'd never hear a professional woman golfer refer *to her buddy* or be referred to as another woman's buddy. *Her competitor, yes, her friend, her rival also, but I will wager that a professional woman golfer has never used the word buddy* in regards to another woman professional golfer.

Buddy's only a word, Jack says, not something to get worked up over.

Only a word, I say, only a word? *Is golf only a word*, I say, or birth or death or copulation? Are those only words?

Well you're my buddy, Jack says, and I hope I'm your buddy. As for the the rest of the *world? Don't you see that it's made up overwhelmingly of people we don't want to have in our lives whether we think of them as buddies or not*, Jack says.

I call Jack my *friend because Jack is the only one who does listen to me*; he speaks to me by listening. I can tell Jack his sweater is ugly, and he can tell me that he's afraid his wife doesn't love him, and trust these things will remain between us.

I asked Jack once, *Who are you? Do you have even the vaguest idea who you are? Knowing yourself in the most difficult thing in the world, a real-time performance in front of the harshest judge imaginable—YOURSELF.*

I know who I am, Jack says, *I play golf*, that's what I know.

Jack, I say, **knowing's such a vague notion** though by now *knowing's* embedded in our constitution. The concept of knowing is a false premise very few men running things will admit to being false. *Knowing* is all about having the upper hand, of maintaining control, that sort of thing. The men running things pretend to know what's right, knowing in their hearts, should they be lucky enough to have hearts, that they don't really know.

Knowing's actually a disaster. Knowing, we've reached the highest citizen-to-lawyer ratio since the fall of Rome, a glimpse of the future that's soon to come. Scientists at least admit they both know and don't know. I once heard a world class physicist define outer space as *a place that's blue and birds fly in it*. Doctors don't know, they only act like they know. Every once in a while there's a good doctor, a doctor who will take the time to look you up and down like a fellow human being with the idea of finding out what's wrong, and then try to heal you or at least give you some decent advice.

I think I understand what you're trying to say, Jack said, **you have to have the appearance of knowing**, to be thought of as being able to take the lead. There are committee meetings and assignments, responsibilities and so forth, Jack said. *You have to show up on time, do what you say you're going to do, honor commitments*, but rarely in the back of your mind is the question being asked, Is this the right thing to do?

Our huge insurmountable social-political problem: we've made leadership too easily obtained, I said to Jack, in fact we've made it easier and easier for sub-par people, either belligerent idiots and marginally literate tv personalities or slightly above average lawyers and salesmen to become leaders.

Why do we continue believing our leaders actually want what's best for us, or even know what that might be! Don't we have enough evidence to the contrary? It doesn't matter what we call it—democracy, autocracy, dictatorship—our leaders are mostly incompetent and dangerously pious, mostly men, or even worse, celebrities, I said to Jack. *Once in awhile we get a decent leader, every thousand years or so*, not a truly good leader but a leader who does only a minimal amount of harm.

Our imperfections have grown over the years, and they're pouncing on us. We're all victims now, I said to Jack. Leadership's become some sort of game and we've become

truly miserable at it, killing one another, pounding the ground in agony, groaning, going to big conventions on behalf of the company, putting on nametags, support stockings, pantyhose and cufflinks, showing our best faces hoping to be noticed.

Let me say what I think you're saying, Jack said. The overwhelming majority of men don't like to play golf with women and there are also many women who don't like to play golf with men, which is surprising to men though not to women. *That the original imperial-colonial instinct of the superiority of one kind of human being over another is regulated by golf's form of birth control,* Jack said.

That's more or less what I'm saying, I said to Jack.

Then Jack said, *all you've said might be true but I imagine it must be pretty nice to be a celebrity.*

Then Jack says, *I have the feeling my wife only tolerates me,* that we've reached the stage of mutual toleration in our relationship. She tolerates me slightly more than I tolerate her, or I tolerate her more than she tolerates me, but *there's very little equality in our toleration of one another.* We no longer deliver love to one another as we once did. O, we have sex now and then, *Jack says,* but the best thing by far about sex at this point is just being with somebody else.

Jack pauses to show he's really thinking. Then he says:

I really don't want to become one of those guys who have to have a woman telling him how great he is all the time *like so many guys I play golf with. Or who end up with the question late in our lives, why didn't we love one another more?*

Everything of meaning in my life has been negative, I tell Jack, *everything. I'm the beneficiary of the negative, a profiteer.* <u>I learned almost exclusively from negativity</u>. Had I not had the benefit of the negative, I wouldn't be who I am today. *I think of negativity as a form of genius,* I say to Jack.

The negative was installed in me from the beginning, from the first words that I was able to understand from my mother and father, who'd had the same words drilled into them from the beginning of their own sweet but disastrous lives.

It was my father, I said to Jack, *who instructed me to play games in the first place.* 'Dad', as we called him, was so good at showing us what not to do. *There were others along the way, 'mentors' they're now called, and I soon saw a pattern repeating itself.* Whatever the so-called towering figures of my youth said—my father and mother, the Sunday school teacher, the scoutmaster, the basketball coach, the ones who were themselves mentored so that they could mentor me—meant almost nothing, and I learned that *if I did the opposite of what they said I was on the right path*, things usually turned out the way they were meant

to. In Sunday School for instance, sometimes I prayed and sometimes I just pretended to pray and sometimes I didn't pray at all...

I could tell Jack wasn't listening, that he thinks I'm boring, or he was half listening which shows me how boring he is. Jack hadn't heard a word I said! He really didn't care. I was the liberal and he the conservative, that's the way it is, the different camps we were in.

ARE YOU LISTENING TO ME? I say to Jack, in a louder tone than the tone I ordinarily use.

I'm sorry, Jack finally says, *you're the poet. Give me the briefing in as few a words as possible.*

I was my own mentor. I mentored myself, I said.

I'll never forget what Jack said next.

I know only one person who escaped their parents way of thinking. It's almost impossible to escape, Jack says. *People almost always think exactly how their parents thought; if conservative, then conservative, if liberal liberal. A few become free by not caring; they're the lucky few,*

incredibly rare. The worst are conservatives, and I'm one of them, especially the children of conservatives whose parents themselves were conservative—there's a great country western song I remember hearing once in a bar in Wyoming of all places. Liberals are pretty bad too, basically depressives, able to roll their eyes, make funny faces at things they don't agree with and drink wine at the same time. Liberals seem a bit more polished at talking sensibly about poverty and injustice and climate change, though it's just talk. But conservatives are absolutely the worst, Jack says.

So many conservatives think of themselves as independent thinkers too! It's truly hilarious! The more conservative they are the more they consider themselves as completely original thinkers. It's quite difficult to think, to actually think. Thinking seems beyond us now, like a galaxy which we're so pleased to be looking up towards, thinking that we're really searching for truth, failing to take into account the great distance, the price we'd have to pay to actually reach for the stars!

Conservatives tinker around with thinking until they seem to truly believe they're thinking their own thoughts, borrowed from one crackpot after another, led around by the nose by their parents who were of course led around by the nose by their parents and so on. *They never admit to being influenced either; instead they think of themselves as free independent thinkers.* But if you look at the choices they make, what they choose to talk about, who they vote for and where they get their information, their world-view turns out to be a creepy slushpile of twisted truths, confused half-facts, opinions received from television personalities, and so called

think-tanks. These people who call themselves conservative were actually brought up to believe that almost everything's a lie, except of course what Jesus is supposed to have said. *No wonder conservatives are such big believers in conspiracy*, Jack says. *Conspiracies are comforting to these folks, they make the same sort of sense of the world that Jesus and his followers made.* To the conservative the world's run by one conspirator after another instead of mostly average, sometimes stupid but exceptionably humble civil servants who make simple mistakes whether they mean to or not. In this regard—the assumption that any and all government is evil—the Right has turned into the Left and the Left into the Right, Jack says. Neither has any basis in reality! To the conservative everything's a conspiracy and to the liberal everything's a mediocrity. The political scene's so dreadful that the great George Orwell is claimed by both conservatives and liberals as both hero and a villain.

Episode 27

Jack can't stop.

The Lefties are pretty awful too, far more riddled with neopotism than The Right—that dad was a famous leftist who did good for society and the kids wanted to follow in his footsteps, or they just got lucky and went to the right school—the kind of people who take a look at the solar system, the stars, and say to themselves 'why go there anyway?' 'What's the point?' I'll just stay here on earth, look out the window, count sparrows and think about not doing anything more than's already been done. But at least the

liberals are slightly more likely to admit failure and to say a few soothing words once in a while about peace and love and nuclear disarmament, though the sentiments are purely cosmetic.

These aren't complaints, they're merely observations, not dissimilar to the distinction you make between reality and negativity, Jack says. *I was raised a conservative,* I'll always be conservative. *I know this tribe. They think they're smarter than everyone, they really do,* that they have a better product and a system calibrated in their best interests to serve it. *And the more they claim to know of course, the more dangerous they become,* noxious creatures of a venal underground…

…the trouble is that we seem satisfied with the way we are! It appears we no longer want to build a way of living that we'd want to hold on to or grow old with. We seem to believe we've wrung out all we can possibly get for ourselves as individuals…

I can't be sure if Jack's finished his remarkable soliloquy, so I let a few moments of silence to fly by.

Episode 28

I guess I was lucky not to have a mentor, I finally say to Jack, and to have had next to zero parental influence politically. You also might be interested to know that I've thought for a long time that there's *only one question a candidate for political office needs to answer correctly:*

<u>*can you change a diaper?*</u>

This is the very same day I tell Jack I'm writing a book about golf, preliminarily titled, 'Golf is Ruining My Life.'

how to play football on a golf course

You'd think there'd be a lot to talk about while walking toward a golf ball you've just hit, Jack said the other day, but it seems silence is the most interesting thing as we trudge along, all thinking the same thing, *will I find my golf ball or won't I?* And once the ball in question is found the question becomes, *am I in the right position to attack the green?* Jack said.

I understand what you're saying, I say to Jack, that we're all walking down the same fairway together in the brand new autocratic order of things. I do listen for someone to say something interesting, *I try to listen, I could listen more,* I say, I try to pay attention, to perk up whenever something new is said. *But less and less interests me now,* in fact *only those things I'm disinterested in seem of real interest to me now.*

I try to introduce new topics on the golf course, but when I do I'll get a look from one of the group that says, *Did I hear you say what you just said?* but with no authentic curiosity. I'm often tempted to think, *was it really me speaking to three other people who aren't listening? Am I the only one hearing the words I've just said to myself?*

I overheard you say yesterday, Jack says, that *you now think of death as the next great adventure!* I could see from the moment you spoke that all who overheard believed there to

be something very wrong with you. *But you followed with an unexpected string of good holes,* Jack says, where you hit one nice shot after another, regaining their respect just enough to be listened to. *It was then you told me you were writing a book about golf,* Jack says.

I shouldn't say such things, I tell Jack, *I know better.* I've *learned never to talk about domestic politics on the golf course,* the best golf lesson I've ever had. No matter how informed I am, how many newspapers I've read or novels of the Austrian avant-garde, how diligently I've studied the actual history of my country, I'm always on the wrong side of the issue, no matter what I say or how much intelligence I can muster for the discussion at hand, I'm always overcome by the certainty of the other side, the superior viewpoints of all those who oppose me. *The men devoted to golf will always know more than I know about domestic politics, always being on the right side of things,* I say to Jack.

Episode 3

Doesn't anyone ever get tired of lying? I say the other day to no one in particular. *It seems that an inexhaustible corps of international liars have taken over, one after another, who can't wait to get in and take control,* as if they really believe their leadership will release us from all previous mistakes past and present?

We're at the proverbial crossroads with no proverbs in sight, Jack says, *Is that what you're saying?*

*Speaking about geopolitics on the golf course is something
I'm only now becoming comfortable with*, I say to Jack. Very
few golfers know where Yemen is or that Grenada's an island
in the Carribean, believing they actually might be places
mentioned in the Bible. They'll only pretend to hear what I'm
saying only as long as it's from the perspective of living in *the
greatest country on earth* or wearing a metal American flag
in the lapel of their sport coats.

Jack believes the people we play golf with might not
understand domestic or international politics but they
might understand what he said yesterday—that **golf is
existentialism upside down, the elegant European way of
tying yourself up and beating your head against the wall
after promising never to do such a thing ever again**.

Episode 4

The next time Jack and I golf together he says, *Your book
needs an arc.* This from a man who cannot hit a decent
9-iron, the second easiest club in the world to hit.

*In every book written, from the classics to the Bible, certain
episodes should be left out and other episodes left in,*
I say to Jack.

It seems Jack and I both have a great need to be right,
while also knowing it's terribly wrong to need to be right.
We're learning to leave what we've just said to one another
right where we've said it and just walk away like it hadn't
happened.

LAND RAILWAY COMPANY'S
COURSE
T
RROLL

NEW G.N.S.R
HOTEL

45 YDS
250 YDS

MARK
BEACH
STATIONS

20 CHAINS
500 YARDS

MARKER	Hole/Name	YARDS Champ Blue	Medal White	Society Green	Par	Stroke Index	SCORE Player A	Player B	Win Los Half Points
	1 Hughies	392	382	371	4	7			
	2 Giant's Grave	505	490	477	5	11			
	3 Islay	155	145	140	3	17			
	4 Fred Daly's	457	455	442	4	3			
	5 White Rocks	384	379	369	4	9			
	6 Harry Colt's	189	185	177	3	15			
	7 P.G. Stevenson's	431	418	415	4	1			
	8 Himalayas	384	363	358	4	13			
	9 Tavern	475	472	456	5	5			
	OUT	3372	3289	3205	36				
	10 Dhu Varren	478	475	461	5	10			
	11 Feather Bed	170	165	160	3	18			
	12 Causeway	392	386	367	4	2			
	13 Skerries	386	370	358	4	16			
	14 Calamity Corner	210	202	195	3	12			
	15 Purgatory	365	360	355	4	4			
	16 Babington's	428	409	404	4	14			
	17 Glenarm	548	528	504	5	8			
	18 Greenaway	469	457	413	4	6			
	IN	3446	3352	3217	36				H'Cap
	OUT	3372	3289	3205	36				
	TOTAL	6818	6641	6422	72				Net
	S.S.S.	73	73	72					

Marker.

Player.

Royal Portrush Golf Club
Dunluce Links

Practice Ground

Royal Portrush Ladies Clubhouse

Pro Shop

Royal Portrush Clubhouse

Practice Ground

Bushmills &
Giant's Causeway

Portrush

N

When I first play golf the kind of life I was living comes
to an end, and another begins without me knowing what
is happening.

I buy a set of used Tommy Armour 845s. A year of so after
attempting to play golf with them I find them inadequate,
tossing the whole set into the pond beside the 7th green, an
expensive deus ex machina maneuver in which I am both
liberated from the ground beneath me and feel I've made a
great mistake at the same time.

That night in bed, guilty of destroying private property in a
self-created act of anger, then chastened by a conscience
I didn't know I had, I dreamed I'd tossed a bag full of
previously owned Tommy Armour golf clubs into the pond
until what I'm 'dreaming' is the kind of nightmare I'd never
experienced before.

The morning after this watery conflagration I begin having
different feelings about golf.

It's true I distrusted golf at the beginning—it wasn't
something I'd done as a child—but now I've actually begun
to believe golf might be giving me a new kind of life! Perhaps
it was possible that I could develop a relationship with golf
until it became something I wanted to do both more and

more and less and less, a kind of new balance between being happy with the performance of my golf clubs and wanting to throw them in the pond.

I once believed golf's for people much younger than I am, I say to Jack the next time I see him, *people closer to the age when it's still possible to have fun.* And that from age twelve I should have already been a good golfer or given a series of tests meant to be failed, which was indeed the case. *It's a whole long story*, I said, *way before my golf* life. I was 9 or 10 years old…

Jack says he wants to hear my story, but not now, *tomorrow or the next time we see one another.*

I fail my first test at age 8, swimming the backstroke on the Fourth of July competition at the Country Club, unable to do two things at once—to go forward on my back—and wind up winning last place. My consolation speech consists of three words, "my socks slipped."

All the other boys and girls whose parents belong to the club are already out of the water and drying themselves off with big soft white towels, looking down on me and trying not to laugh when I finally touch the front edge of the finish line. Some were already junior golfers, whose fathers and mothers wouldn't think of throwing them in the deep end as I was thrown by my father while trying to teach me to swim, then also telling me, "It's no crime to come in last," one of his many mixed messages.

I remember pulling a sopping wet white towel over my head after the event, one of the towels the other kids had left behind, hoping to experience non-existence or at least taste what not-existence might feel like. It had to feel better than coming in last place, but maybe not. Both the towel and I felt unwanted, but the fact that no one could see me under the towel was what I wanted most of all. And it seemed to work, for all I could see were the feet of the people passing by me, and not one of the passers-by said, "I'm very disappointed in you." And soon, after minute or two, there were no feet at all passing by and I was truly alone, exactly where I wanted to be.

I tell Jack, almost drowing in memory at this point, *there are times on the golf course now that I feel like the child I was then, and that time is beginning to catch up with the times I don't want to keep golfing,* much less drive home from the golf course with one large existential question looming— was it really me out there on the course today, or was it someone else?

Yes, it was you, Jack says, *it was you in imitation of a golfer.*

It's true, I tell Jack, that once I started playing golf *I began to identify the problems I have with myself and with the world, with golf.* My big problem is that **I always reach a point in the round when nothing is coming to me**—I'm both

not thinking and having too many thoughts. The target's vague, too close or too far away, an imperceptible beacon. I stand over my golf ball for a more definite signal, but not a speck of information appears. *And then suddenly I'm in a great hurry. I simply can't wait and golf at the same time.* Yet I must do something as they're waiting, my playing partners, they'll only wait for so long before they think there's something wrong with me. But I can't be rushed; the action is all in the waiting. I've acted too quickly before and it's always been to my detriment. *In golf, nothing good ever comes from hurrying,* I say to Jack. *Golf's all in the waiting,* that when I wait I almost always hit a shot not only worth waiting for but that I can record like the highlight of a beautiful dream. Yet they're still waiting for me to hurry, having seen me hurry before!

I have no desire to be profound, Jack says, *but the meaninglessness of golf is its great attraction.* And yet I'm constantly tempted to believe there's no choice other than to take golf seriously, as seriously as I might otherwise take myself. *If I have any intention of continuing to golf I'll either have to start believing in the afterlife* or make some other sort of radical adjustment to my thinking, Jack says.

I make adjustment after adjustment, I say, *often adjusting the original adjustment.* These adjustments, an accommodation for almost everything I hadn't known about myself before golf, feel uncomfortable, like something opposing the way I've always done things.

Playing golf can feel both like a baptism and the death of a loved one, Jack says, his particular brand of consolation. *Golf's either a sport or a game, we'll never know which*, we'll only know it's one or the other, Jack says.

I golf without knowing whether golf's a sport or a game, I say to Jack, coming to believe that golf is neither. Golf is a 'sui generis' diversion from a heartbreaking world full of hyperbole and televised sporting events, or a small mistake made when shaving. It's gradually become the only sport I've played in which, when awake, I ask myself, *Why did I start playing in the first place? Maybe I should have stuck with basketball or tennis*, my birthright sports, I say to Jack. Golf puts me in the position of having to become a beginner all over again.

Where did you get that language? Jack says. **Sui generis**? *It sounds like something you've written, since nobody talks like that*! I'm afraid you're becoming overtly intellectual, either that or an art critic. And either will destroy your golf, Jack says.

When I tell Jack I learned to play football on a golf course he insists on seeing the course for himself, claiming that no one had ever played football on a golf course.

We played a game called 'Kill The Man with The Ball,' I remember it as the most fun I ever had playing golf, but maybe it's only my memory I remember. We were children then, free to make up games, flooding the fairway of the 11th hole at the Golf Club—an uphill/downhill par 4—on a late Sunday afternoon, scampering into the bushes so as not to be seen when a lonely golfer came over the hill looking for his tee-shot, I say to Jack. *There were six of us*—my little pals Jimmy and Mike and Stuart, and the two girls who lived across the street who were better athletes than we were, but whose names I've forgotten.

Episode 13

I drive Jack to the golf course where I once played football. We walk very, very slowly down the middle of the fairway, not a golfer in sight. The fairway, which once looked as wide open as a child's eyes, seems much smaller to me now, an adult who plays golf on narrower and narrower fairways.

I imagine this must be very strange experience for you, Jack says, *and that certain powerful memories are returning to consciousness.*

I'm thinking for some reason, I say, *about the difference between play and golf.* That we're all children when we play, but we don't play like children when we golf. I'm sure this feeling has something to do with time, I say to Jack, that only children have the time to actually play. *We aren't really playing like children when we golf. Golf is the activity of play without the spontaneity.*

56

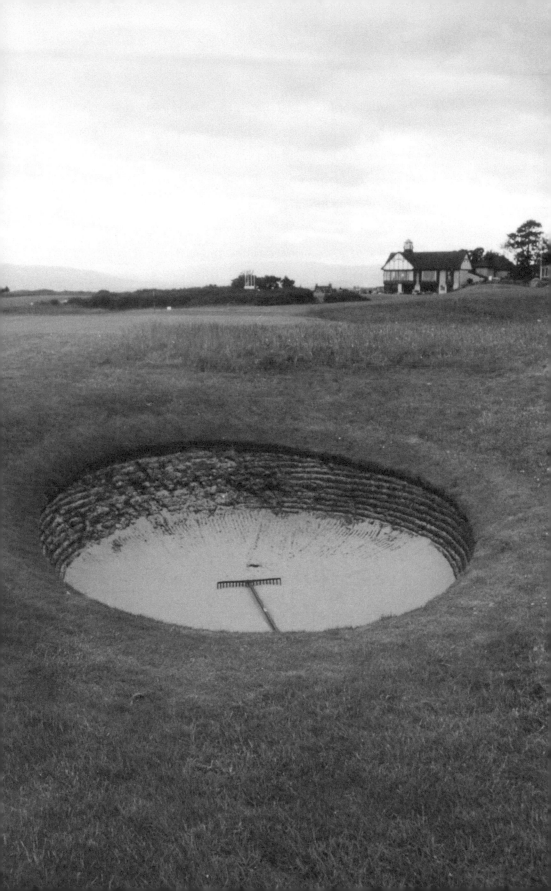

That's so philosophical and platitudinous of you, Jack says, that the most fun we ever have occurs when we are children, when the present is something we never think about and the future has no beginning or end. *Perhaps it's impossible to really play or have fun once one has reached a certain age*, that a case can be made that all fun is achieved between the ages of 2 to 7, that once someone reaches puberty fun is no longer possible. *It has something to do with self-consciousness*, Jack says, *self-consciousness is full of chemicals*.

Standing on the fairway of the 11th hole where I'd once played 'Kill the Man with the Ball', still no golfer in sight, I tell Jack about the many times we were chased off the course by the Head Pro, a man named Bud, a divorced chain-smoker no one ever saw smile, who had custody of his two children and threatened to tell our parents we were ruining his golf course but never did, having a son the same age who did much worse things than flood a fairway and play 'Kill The Man With The Ball' on his father's golf course.

What you said a moment ago provides the arc for your book about golf! Jack says out of nowhere. **The examination of the difference between fun and play**. *This is key*, Jack says as if he's genuinely excited, *I think you're on to something*. Play is a verb, Middle English, archaic if I remember correctly. Fun's a noun, Jack says, as in, *a snake was let loose in the classroom and then the fun began!*

The word *play* probably originated in acts of swordplay, gambling, and sexual intercourse if I'm not mistaken, Jack says. A golfer can say, "He's a player," as we say when one of us is playing well, but a golfer can't say, "He's a funner."

Jack and I drive home from the golf course where I'd first played football in a kind of lingual eclipse, neither of us saying a thing or even opening a window to let the wind in. Jack drove, I read a book. I can't remember what book I read because I wasn't really reading it, I only wanted Jack to think I was reading so that I wouldn't have to talk with him. Jack drove and I played that I was reading a book, neither of us imagining we were having any fun.

Golf Links and _____ ___ay

everything stems from golf

Golfing, I often feel as if I'm riding a horse and walking on my own two feet, beginning with my toes. I must remember to lift off of them, my toes, and have the rest of my body follow from there in proper sequence while not leaving the horse behind, which could be the *arc* Jack referred to when speaking about the book I'm writing about golf.

But the arc fails to materialize. Jack and I spend a great deal of time and money searching for it, but the thing never shows up, at least not in a form either of us recognize. Jack quits searching a month or so after I do. *I guess the arc is basically a fable*, he says, *fancy talk for something that only exists in writers' manuals.*

I'd heard so much about arc that it's almost impossible to accept that it doesn't exist, I say. *I suppose it's a myth like so many of the other aspects of golf.*

Jack knows I'm correct but doesn't want to hear it.

Whether or not the arc exists I enter a time of my life when everything stems from golf. **Whether golf is a sport or a game makes no difference—that everything stems from golf is the thing to dwell on.** I become supra-saturated with everything regarding golf, turning a shade of light green, and

want golf to take all my time, making arrangements around golf without thinking where golf might be taking me.

Just being near a golf course is exciting; I feel what it must feel like to be a small red balloon filled with helium. Driving through the countryside and seeing a large undeveloped tract of land I envision the golf course I might build there, making the course in my image and likeness, a retreat where I can think clearly about *where I want to go, what I want to do, what I haven't yet done with my life, what I want to leave behind.*

The golf course I design begins with a par 4, straight uphill, the green framed by a cluster of oak trees, and then a slightly downhill par 3 near a pond where flamingoes have been spotted. I don't need 18 holes—18 holes are far too many holes—I only need 3 or 4 holes that I can play over and over and over again.

I receive input from the occasional interested party—golfers who've found that most everything in their life revolves around golf before they know what's happening, men and women obsessed with golf in much the same way bibliophiles become obsessed with antiquarian books. Only when it's much too late do these people discover silverfish have gotten into their treasures and are eating the book bindings for all the protein there, so that the book falls apart when it's touched by the person who's survived its owner.

I shouldn't have told Jack that I'm writing *a book about golf*—I really shouldn't have, it was a serious mistake, the same kind of mistake I make over and over: <u>the mistake of getting ahead of myself</u>.

I wasn't born with a love of golf as most golfers are but grew into it before I knew what had happened until I was filled with a form of chlorophyll that makes green grass look greener.

Jack's played golf since he was a boy, no other sport would have him. He was one of those skinny little kids carrying around a golf bag much too big for him who played golf because he was no good at the team sports everyone else played. Jack loved golf from the moment he first touched a club. *No one ever said to me, 'you dropped the ball', or 'why can't you ever make a basket'*, Jack says. Jack's a big pipsqueak by now, a self-made man who's kind of a pain to play golf with. I don't know how much longer I can play golf with Jack. I can't decide whether his love of golf is good for me or if golf is some problem he's having with himself that will ultimately rub off on me, a kind of rare infectious disease.

We meet once a week at the course of his choosing. I listen to Chopin's Nocturnes on the way, often thinking about turning around and going back home, feeling like I'm late or about to be late or only going to make it to the golf course by having to hurry. It's true that I have trouble with

time, and therefore with reality, **but I can't say if this is the way I really feel or if this is the way Jack makes me feel**. According to Jack I'm always late, though I'm not; Jack is always early, no matter how early I am.

Jack golfs like a pharmacist filling a prescription, going through a routine of the same precisely identical movements before he hits a shot, as if he's still in a pharmacist's outfit, trying to make the perfect dosage and then slightly overcharge the patient for the product. I'm less and less interested in watching him do the same thing every single time, taking far too long to hit his next shot and the shot after that. Even more unnerving: Jack's shoes and belt are perfectly white, and his shirt is always tucked in.

Jack likes to give advice I don't take by telling me what I already know. He especially enjoys saying that I *decelerate* when I putt; there's something fussy about the word *decelerate* that Jack likes hearing himself say, saying it on the putting green when we're in close contact with one another and others can overhear. I've told Jack over and over that if I want advice I'll ask for it, but he doesn't seem to hear me or, if he hears me, just can't help himself from offering advice.

What's the worst thing I could say to you? Jack asks.

To say I decelerated, Jack, is not the worst thing, it's next to the worst thing. The worst thing is the silence when you stand behind me as I'm ready to hit a shot and then criticize

me when the shot is mis-directed, saying, *Do you realize you were lined up that way?*—when I hadn't asked for input or for you to stand behind me to watch my golf swing.

Everything in golf is made to be beautiful or is ruined the moment it begins. My right hand is too strong, my left hand suffers in support of the right. Should I look down and not up! Should I take more time or less time? Should I even think about time, or dwell instead on the relationship between the beginning and the end?

Jack claims he plays golf *backwards, from the green to the tee,* and I believe him when I first start golfing, though I've golfed with him enough by now to know he only plays backwards on rare occasions and that playing golf backwards is never his intention. I've also heard it said by decent putters that they *see the ball rolling back to them on a line from the hole they're putting toward* **before** they've hit their putt, which may or may not be true but doesn't make any of them better putters than the rest of us.

I experiment, hearing this kind of twaddle on the golf course, by trying to put twaddle into practice. In retrospect I see how misguided this is, a conceit as mistaken as the notion that IF YOU FOLLOW CERTAIN RULES, LIVE YOUR LIFE WITHIN THE BOUNDARIES OF THE VALUE SYSTEMS ACCEPTED BY THE MAJORITY, GO TO THE CORRECT SCHOOLS, the school approved for higher education, ATTEND SUNDAY SCHOOL and then CHURCH, you will become a better

person (though not necessarily a better golfer or a better artist, architect, preschool teacher, graphic designer, real estate developer, convenience store operator, dentist etc.)

I become an independent golfer autodidactically, fending off Jack and others who say they want to help me, finally getting them off my back by watching golfers much better than I am, imitating their golf swings by trial and error, discovering what works and what doesn't work, though what works one time often doesn't work the next, until I finally stop believing there's anything scientific about the so-called, 'science' of a golf swing.

Two or three years into golf (I can't remember which, was it two or three? Two is such a good number, a slightly better number than three) I discover that the bad golf shot is full of information, far more information than the good shot. The bad shot is the shot one can only learn by oneself. It comes so naturally, both virtual experiment and real life experience, a self-perpetuating lab trial that often feels shocking because it never should have happened in the first place.

The bad shot's not something I can speak to Jack about, he's far too commited to what he thinks is *positive thinking* to accept the idea that one bad shot leads to another, that the bad shot often becomes worse and worse, and quickly turns into two or three bad shots, compounding, like money

is said to compound by investment bankers who use others' money to make more money for themselves. Jack will talk about almost anything other than a bad shot.

Jack, I say, *the bad shot's the most creative shot in golf;* a good shot can't hope to compete with a bad shot. There are almost an infinite number of ways to hit a bad shot, I say—*I looked up at the last possible moment, I hit the golf ball fat,* as golfers love to say, *or I shanked it into some bushes, that my left hand turned the club over at the moment of impact...*

I don't need to hear this, it's extremely negative and very destructive, Jack says, Besides it's nonsense, *there's nothing good about a bad shot.* Hearing you speak about it brings back *horrible memories, scenes that can't be erased. The very last words my father, a fine golfer, a much better golfer than I'll ever be, said to me were, 'I wish I liked you more,'* and then he died, Jack says. Bought the ranch, sat on the plate, cashed in his chips, however you'd like to put it. Kaput! *I wish I liked you more, what kind of thing is that to say to your only son,* Jack says? *My old man's a tugboat I've been dragging around for years,* Jack says, extending the already tortured metaphor. *It's a wonder I don't have deeper psychological problems.* Toward the end of his life I was made to feel *my father was the victim I was accused of trying to kill, but my psychiatrist finally convinced me that it was his deathbed, not mine,* Jack says.

Jack sounds just like a bad shot, the kind of shot a golfer might remember for a lifetime, tucked in bed at a sensible

hour but sleepless nevertheless, walking over, around, and through certain scenes in his life, wondering if he'd done something so evil, something he could never possibly undo, a heinous crime, short of murder perhaps, but cruel and without the possibility of atonement, or if he'd simply been born to the wrong people, people who shouldn't have played golf, biologically inferior people who suffered from a lack of coordination and an inability to concentrate, people who should never have had children.

I don't know how to respond: what I call *reality* Jack calls *negative*.

He doesn't like hearing the story, which I tell over and over, of two very bad golf shots I witnessed that resulted in holes-in-one: an 8-iron that was no more than 2-inches off the ground when it should have had much greater altitude, and a pitching wedge pulled so radically that it hit a eucalyptus tree 20 yards left of the green and caromed into the hole. I even remember that the names of the golfers who hit the wayward shots that resulted in golf's ultimate prize, the hole-in-one, were Don and Jenna, a man and a woman.

It's useless trying to convince Jack of the benefits of a bad shot as either a learning opportunity or a chance to get lucky, but I keep trying.

Every good shot looks more or less the same, I say, *a masterpiece* that flies toward the target with the conscious intention of art criticism written by Tolstoy. *Every bad shot is unique, having its own DNA, and no two bad shots are the same.* Good shots promote other good shots, one typically follows another, but bad shots compound, a gathering of negative atoms that soon form a cluster of bogeys, double bogeys, and triple-helix bogeys.

Episode 11

I could have said to Jack, **let me be clear—bad shots are never good shots.** He would have understood the conceit if I'd said it that way.

Episode 12

I still take the bad shot personally, but with philosophical acceptance as if it's not me who's done it, able to see the bad shot as a kind of breakthrough: that I'm finally accepting myself as I am, knowing there were at least a dozen different ways I could have lived my life before finding one unique to me.

I don't say anything now when I hit bad shots. At most I might put my hand on my hip or shake my head and look into the far distance as if seeing nothing at all. **Any words I might say are always the wrong words**, said in much too loud a voice. I keep quiet instead, though it does sometimes seem as if silence is getting away with something that should be said out loud.

After two or three years I come to appreciate golf for its *foregoneness*—that everything in golf is personal and consists solely of individual destiny, pre-ordained the moment I take my club back to strike the ball. And that old behaviors and habits often catch up with me at impact, for everything in golf has already happened in the past.

Trying to live up to golf at the moment is the best I can seem to do, but I struggle, knowing nothing good ever happens when I swing too hard or too quickly, or even too, too smoothly with the abbreviated follow-thru recommended by some of the finest 'giants' of golf.

I begin to read philosophy again, as philosophers and poets are the only ones who really know anything. "The condemnation of an error is another error," says Antonio Porchia, poet and aphorist or aphorist and poet, I can't remember which, knowing him primarily as Argentinian.

The first philosopher I met was on television, a black & white set with 'rabbit ears'—splayed antennas set on top of the TV hoping to pick up the signal. A formally dressed journalist named Eric interviewed the philosopher, a longshoreman from San Francisco, who sat in a chair opposite him. He

asked the philosopher questions for 15 minutes or so— how he came to be a philosopher, where he got his ideas, how he lived in the real world and so on. The philosopher said he was "really very average", and quoted Goethe: 'I've never yet heard of a crime that I couldn't commit.'

I wanted to become a philosopher from that moment. I was 12 years old.

A philosophical quality I call *Golfness* becomes intriguing, that some golfers have *golfness* and some never will. It's like finding someone *sexy*—you can't always put a finger exactly on what you find sexy about them but you know they are, finally realizing it's because they show you something you already find attractive in yourself but hadn't yet noticed.

I start smoking again, but only on the golf course, believing that **to a golfer who hopes to achieve golfness, smoking is thinking**. And since thinking is especially excruciating for the thinker, the smoke of a cigar or cigarette is a good friend on one's journey toward thinking and golf.

Why do we keep pretending there are great men? I said to Jack yesterday. There are no great men. There are no great men because we've been pretending for so long that there are. *There are only great women.*

Also on the rise are the number of times I say *Huh* to Jack and he says *Huh* to me after one of us gets a par, *as in, Huh, you got a par?* each of us in disbelief of the other's success.

Episode 18

I've just noticed Jack wears an necklace—a small gold chain from which a thin silver strand dangles. I hadn't noticed it before and feel I should say something about it.

Jack, I would say, *What's with the necklace?*

There's no need though to turn it into the kind of Q and A that takes place between writer and reader in the pages of literary quarterlies, as in the case of William Burroughs, *interviewed in The Paris Review* not long ago before his death:

Q: What is the symbolism of the lesbian agents with penises grafted onto their faces, drinking spinal fluid? A: Oh just a bit of science fiction, really.

Better to say nothing to Jack—the necklace is self-evident. Were I to wear an necklace or an earring or any other

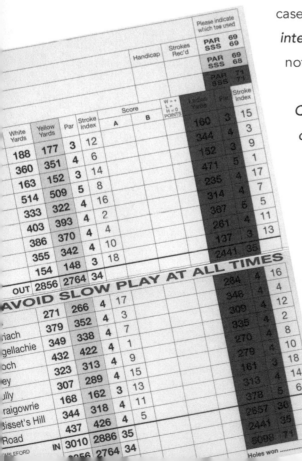

sort of jeweled adornment I wouldn't want to be asked about it. Besides, golfers are born with a preternatural absence of curiosity about others, if curiosity is defined as thinking for yourself and not as your parents or the so-called role models or mentors in your life thought. A golfer's only interested in himself, a completely imperialistic way of being in the world.

are men as crazy as women
or are women just as crazy as men?

Jack's just returned from an 8-day golf trip to Scotland, though he never touched down, having a panic attack the moment he boarded the airplane in San Francisco, escorted off the aircraft by a squad of unsympathetic security agents, the victim of some sudden undiagnosed dread, the origin of which is unknown to him to this day. Scotland was his dream, the golf vacation of a lifetime, a trip he'd talked of taking for many years. He so wanted to plant his flag in what he loved to call, 'The Birthplace of Golf.'

I can't imagine the shame, the total waste of unrefundable resources that Jack endured. It's painful imagining his seven traveling companions, the ones who remained on board the plane and continued on to Scotland to play golf for 10 days (Jack, whose idea it was, was meant to be the eighth). They keep their distance from him when they return home. Nothing obvious at all, only the subtlest of exclusions; no more invitations to places where he was once invited, last minute cancellations of lunch dates and tee-times, a wave of the hand from across the hall instead of a handshake, the typical minor social indecencies of men who think of themselves as good men, as people born to only do the right thing. So that Jack now feels outside the circle of their friendship. *It's like they're writing a gossip column about me,* Jack says.

Disclaimer: it's well known that Jack has big ears and that he's a talker, able to do both at once, talk and listen. My feeling about Jack, after learning of this incident, is that he looks and talks like a rather big sheep dog who's just had the front door closed on him and has been told to sleep outside though he'd just been inside asleep on a rug in front of the fireplace. And there's always something in Jack's eye, a small bug or some other pest, just enough for him to blame it for the bad shot he's just hit.

Psychologically, Jack's big problem: that he never found a nickname he liked or that stuck whether he liked it or not. He was un-nicknameable. *Just call me Jack*, he said. I never knew if Jack was his real name or not. I know he had at least one wife, some grown children somewhere, and that the children were all failures (*terrible disappointments* he'd say, shaking his head, offspring that depended on him and would until the day he died) and *the best thing that ever happened to me* the next.

As well as I knew Jack I didn't know him at all. I knew his last name, so mellifluous it sounded as contrived as an alias, JAXSONY, <u>and that it did not rhyme with money or honey</u> as Jack made clear.

A nickname wasn't for Jack, nicknames were for other people and Jack used them illiberally with no ill will. Jack loved a good nickname, always curious about attribution and derivation. *You can't peel a good nickname off a man, once it's there it's there forever*, Jack liked to say, *a kind of tattoo.* All of his friends had nicknames, ironically many of which he'd given them, and so his exclusion from their circle was especially hurtful. **All I can think of these days is how many people I haven't made friends with that I could have,** he says.

Most men I play golf with I know only by their nicknames— *Fallen Man, Banjo Hitter (about whom more will be revealed), The Beekeeper, Irish Donald, Clay Boy, Hackin Bob, Vicious Little Guy, Alex the Plastic Surgeon, The Butler.* I can't remember how The Beekeeper got his name. I do remember he kept a bottle of vodka in his golf bag and the bottle was always ¾ full, a mystery as Beekeeper drank a great deal of vodka on a daily basis, never losing a golf ball, always finding his ball no matter how lost it was. And that *he* became a *she* at some point, though by then I'd lost touch with *them.*

Banjo Hitter, small in every way possible, a little guy who got the most out of smallness, not hitting the ball very far but hitting it straight as intended. I remember too that what little hair he did have appeared to be in the process of deciding to go elsewhere, so that he had less and less hair every time I saw him. He insisted, without exactly saying so, that I name

him *Banjo Hitter* by the way he looked on the golf course, though I never called him *Banjo Hitter* to his face. I called him *Brian*, his real name, or *Sir Brian*; we only called him *Banjo Hitter* when he wasn't with us and could be talked about freely, a short hitter but a far better player than we'd ever be.

Once in desperation I turned to the Banjo Hitter for golf advice, hoping to learn the secret of his accuracy.

I think of only one thing when I'm on the golf course, he said, but didn't tell me what that thought was. Each time I asked he'd say he'd tell me the next time he saw me. I had to ask him again and again, and when he finally told me the answer was so obvious that it was a great disappointment.

Fallen Man claims that when I hit a bad golf shot I *look away* as if not wanting to see a crime, and that he feels responsible for watching where my ball is going and where it might come to rest. It's true I don't want to watch the eventual outcome of a poor performance, but Fallen Man shouldn't worry: I'm aware of the general direction the ball has traveled, having hit it in the first place.

Vicious Little Guy and I spoke once about the journey of a golf ball as being comparable to the transition from childhood to maturity—the most absurd journey

imaginable—but it was only a brief conversation while walking toward a golf ball that would eventually be declared lost.

Vicious Little Guy is long gone, having kept a lit cigar in his mouth from sunup to sundown. He sold fish for a living, paid his taxes, as responsible a citizen as could be hoped for, and obsessed over the kind of poor political leadership we all suffered under, wanting all the money he'd paid to the federal government, as well as to tax-deductible charity organizations over the years, returned to him with interest.

Episode 7

I can't remember who I was playing with at the time, only that it wasn't Fallen Man and he had no nickname. Whoever it was—he wore dark glasses and smoked cigarettes—said, *I almost always find my ball and if not finding it, go on to better things.* From there we spoke about whether it is better for a ball to hit a tree or the cart path; both of us agreed to compromise—we agreed the cart path is preferable though it can do great damage to the golf ball, and that hitting a tree brings up the truly unexpected as a golf ball bounces irrationally once it hits the tree, trees being one of the most beautiful facets of nature that are completely irrational. There's also the possibility that the ball stays in the tree, particularly a Monterey Cypress, in which case the Rules of Golf allow three minutes for the ball to drop from the tree with no penalty, or not drop and be declared a lost ball.

deep in thought it's not my fault

By now I'm in deep, whatever *deep* might come to mean as being *in deep* is always more a feeling than a thought. I'm in over my head too, though it's not my fault. In golf the fault lies elsewhere, up close and very far away, the fault lies with something that's wrong with someone else, not with me.

It's not my fault—the fundamental law of golf: to accept the least possible responsibility for a poor golf shot, looking *away* and *not into*; to step aside with at least some grace.

It seems I've killed a duck.

That I kill the duck is not my fault. I hadn't meant to kill the duck though I did have a *foreshadowing*, a literary effect that hints at something bad happening before it happens, as the duck was standing no more than ten feet in front of the tee box. I topped the golf ball while hitting it very crisply; the ball that should have flown upwards stayed instead on a near ground-level line, striking the duck with great speed somewhere between the midriff and the head, vital organs indeed, so that the duck was instantaneously dead.

I had no control of the situation by then, it was both too early and too late to either accept or deny any responsibility.

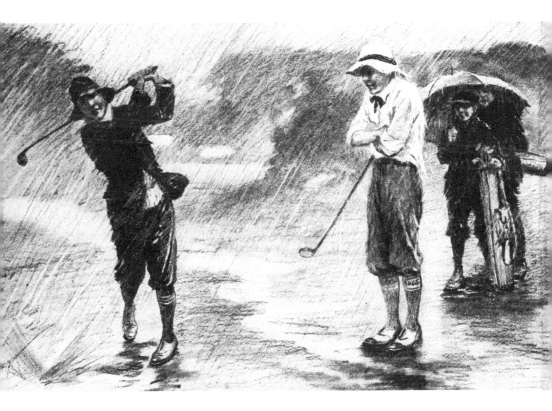

Instinctively, upon news of the duck's death, I went to *First Thought* etc. and its attendant processes.

First Thought: that killing the duck proved that I had no heart!

Second Thought: that my shot had failed so miserably would allow other golfers to judge me as an even poorer golfer than I am.

Resolution between Thought One and Thought Two—**the duck shouldn't have been where it was in the first place**. I'd hit the ball from a tee that was sloped slightly downhill—a downhill lie is always a difficult golf shot—and I looked up from the ball at the same time I was swinging the club, a colossally forgivable error. ***It's I, I, I, I, I, I ad infinitum, the I who is always the culprit, that must always take responsibility***.

Killing's a big deal, at least it's always been that way in my family, but this particular incident really wasn't my fault.

Stunned by duckdeath but not seeing a way I could take complete responsibility, I settle on the idea of *accident*. Even though the word *accident* has certain structural and

problematic weaknesses. It's the best I can do at the time. If the word *fault* made more sense of the situation the duck was as much at fault as I was, the duck should have been up in the air flying or floating around on a duck pond at another golf course than the one I was playing. Compounding the problem, I can't find my golf ball after it hit the duck, nor could I look at the duck I'd killed as I walked by it, knowing it was dead.

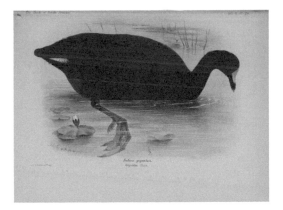

One of the golfers declared my ball *lost*, though how it became lost is still is a great mystery to us both. He urges me *to move on*, disturbed as I was by both the death of the duck and the loss of my golf ball. This man, older than I by a longshot and in retrospect a saint, put his arm around me while whispering in my ear, *It's the great circle of life.*

And it wasn't a duck you killed, he whispers, *it was a coot.*

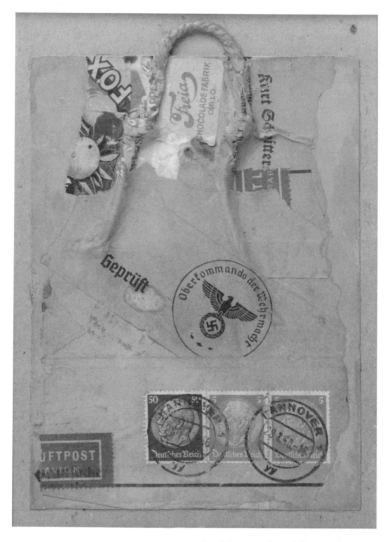

Kurt Schwitters, *Geprüft (Inspected)*,
1940, stamp, string, envelope, and paint
on paper; 6 1/2 x 4 1/2 in.

According to the man who offered consolation, a distinguished professor of Chinese history at the University of Menlo Park, California, the Rules of Golf dictate I have five minutes to find the ball I never found.

An hour or so later we're standing on Hole #8—I can't remember who we were, only that there were four of us and one was a professor of Chinese history—a long par 3 straight into the wind.

I can't decide what club to hit. I should hit a 3-wood, loving the sound of its name—**3 wood**—knowing that the hole's the right distance for its name. Once upon a time the 3-wood was my favorite club. I don't know what happened, my ability to hit a 3-wood disappeared without my noticing anything out of the ordinary had occurred. Another club took its place, the 6-iron, which is now my preferred golf club though the 6-iron has a very different purpose than the 3-wood, and the hole I'm playing is much too far away for the 6-iron.

I waver between lack of courage, self-consciousness and doubt, taking the 3-wood out of the bag and putting it back in, taking the 6-iron out, putting it back, and so on.

Finally, I choose the 6-iron etc. etc.

Because I'd killed a coot only four holes prior, I hoped to insure I wouldn't kill another, choosing the club that I thought had the best chance of lofting the ball well above the coots as they waddled across the fairway or lay on the grass not far from the green, my target.

Nobody understands my struggle—it's as if I am walking in a circle that I've made with my own hands but am getting lost in it and can't find a way out. "*It's not easy being me*" are words I often feel while playing golf but have yet to say out loud on the golf course, fearful of the repercussions.

Episode 8

The day I have difficulty deciding which club to hit is the day I realize I'm playing golf in the era of half-smiles. Of being cheered up mostly by money. Of side bets being made on side bets being made on side bets. Small amounts of money that seem large to some of us and large amounts that seem small to others are won and lost from week to week, or re-lost and then re-won. I can't keep track; I wasn't made for the simple arithmetic of golf money or other investments made by others on my behalf.

Jack says it's not as bad as I think; if I put $100 cash in my golf bag at the first of the year I'll come out even, that I might even be surprised at the end of the year to have come out ahead.

Playing golf for money, Jack says, **is how I became a serious man.** I played with money I didn't have, or money I wished I had or hoped to have someday. *Playing golf for money has made me a better person*, Jack likes to say. *I'm much more honest with myself now* than I was when I only played golf for fun or for beer now and then.

Playing for money I sense the group just waiting for something terrible to happen, I say to Jack, for one of us to hit the bad shot the others are waiting for and will pounce on, capitalizing on another's misfortune, but silently so that others can't tell who said what about whom.

Here we are, I say to Jack, *finally at a place in our lives when we have a little money to wager and are finally ready to hear the truth but have trouble finding any other honest people besides ourselves.* We have all these so-called communication skills, but can't communicate. *And never has there been so much to communicate*, I say to Jack.

My feeling is that gambling's been taken to its ultimate extremes, I say to Jack. *It's a slimy professional enterprise in which only the rich get richer, the ethos of systemic capitalism.*

Jack seems to be listening.

A great athlete is indeed a rare and beautiful being, I say, *but what could be more ludicrous than professional athletic*

competitions? The Super Bowl, The World Cup and The World Series, the world championship of this and that, none of which mean anything other than to the millions of us who spend our time watching them, competitions that are totally meaningless in and of themselves and only fuel the lust for All Things Corporate, I say.

And something has to be done about the whole notion of heroes, and the people who believe in heroes, especially the heroes of sport. *Who are these people who wear hats with the name of their favorite sports teams embroidered on the bill? Frankly, it's embarrassing.* I'd like to give these hero-worshipers a good talking to. *Don't they have anyone other to admire* than men and women who are, in many cases, even dumber than they are?

I've been in the locker rooms of professional athletes after a loss—there's no more dramatically sorrowful, storyboarded mise-en-scene in the world! A concrete dungeon, muffled silences, the big overgrown heads of grown men held in their own hands, having stripped off their uniforms, sitting on wooden stools with white towels around their waists. *The faux solemnity is enough to make you a socialist,* I say. You just know they're trying not to laugh, if only to relieve the so-called pressure, having to make a show of their disappointment being losers and at the same time knowing in their souls the preposterous charade of the whole thing. *Having made fortunes playing games that children play they must see the hilarity—that the sun will come up, the contract will be honored, the millions of dollars they made will be deposited in the bank no later than tomorrow.*

Regardless of their so-called heartbreaking loss, I say to Jack, they must at least pretend great sorrow at losing, shed a tear, give a disconsolate interview to a broadcaster without betraying the meaninglessness of the event.

Episode 10

After my rant about hero-worshipers, gambling and the hollowness of professional sports, Jack still claims he's never played golf without playing for money and seems to be proud of it.

It's the system we've made, Jack claims, competition makes the world go round. *What's the point of doing anything if there's nothing at stake*, Jack says.

Who cares if golf's a sport or a game, Jack, says. *Golf compares unfavorably to the fall of Rome, a fall which historians now claim was overstated.* A little wager between friends on the golf course isn't necessarily a bad thing.

Well, what is the point? I think. I suppose Jack's correct! If doing nothing is the point and there's nothing at stake then I guess I'll keep score.

Jack usually keeps score, he enjoys the control of it, especially asking whether you made a double or triple bogey. **What did you get on that hole?** Jack loves to ask, knowing you'd done poorly and knowing too the exact number of strokes you'd taken, asking not once but two or three times, pretending he hadn't heard you so that you'd have to answer over and over, and in a loud enough voice so everyone in the group could hear.

Playing golf with my own money I'm one among the men I play with, having entered into a kind of aboveground secret bunker where a small unincorporated business venture governed by unwritten and unspoken by-laws and a code of conduct written in-between the lines of old jokes we've all heard before.

The least skillful golfers are always the most memorable, **the ones who have little or no cash and yet love to play for more money than they can afford and who'd play golf only if there was money involved**, the miscreants,

reprobates, the grossly overweight late middle-aged bachelor with two bad knees and one bad hip who crams 8 cans of beer into his golf bag and carries his whole life around as if his favorite golf course is stuffed inside—what's in his bag is probably all he has to his name. These guys have the best jokes—not always brief but often brief enough to be remembered, never layered or complex or literary—often with philosophically sophisticated nuances that make you want to laugh. The jokes I remember are always the ones I can't re-tell, having already been told so well by others, though after playing enough golf to think of myself as a golfer I realize that any one of us—man or woman—have only 3 or 4 jokes to tell at most, and that once you've heard my jokes and I've heard yours there's very little left to say to one another.

Episode 13

I entered a Skins Game yesterday, for a reason I'll never understand, in which a great deal of money was involved.

I hadn't slept well the night before. Once again, questions kept me awake. Sleepless, I posed the same old question over and over, making a picture of it in my mind until the impossibility of there being an answer is beyond doubt. Then, so contorted with insomnia that I feel I'm locked in

a prison of unanswerable questions, I asked yet another question: *60 yards from the green should I hit a low scudding shot as close the ground as possible with a 7-iron, or should I hit a high, lofted shot with a 56-degree wedge?*

This sort of question takes a toll mentally and physically, provoking the sleeplessness I suffer from so often these days, an insomniac who plays his best golf in bed, sleepwalking the fairways, either re-playing the good shots I've hit or picturing good shots I might have hit or will hit someday.

At some point, usually early in the round when my eyes are closed, my shots are most likely to be along a path of personal virtue and individual competence. I hit a 5-iron properly and watch it in the air for as long as it takes for me to fall asleep, reaching into my bag for the whiskey, making par on every hole before I finally pass out.

Episode 14

I recite poems in my sleep, having several memorized from the first line to the last and dozens of other poems from which I remember two or three lines. A poem will come to me as if out of nowhere, WB Yeats' poem especially, "Second Coming," *the best lack all conviction, while the worst are full of passionate intensity.* Yeats' poem is a winner, it golfs me. I re-play the lines of the poem as I walk down the fairway—one never *walks up* a fairway, one always *walks down*—thinking: why is it that the worse the golfer is, the greater are his or her expectations?

Not yet asleep, I ask myself: *Do I have a good swing?* I've been told by other more experienced golfers that if I see a bad golf swing I must never see it again. Most golfers have too many commas in their backswings; some have nothing but question marks.

I turn my back on almost all golf swings now, grateful I have so little talent for memorization—no matter how diligently I try to memorize soliloquies from Shakespeare or a poem by Robinson Jeffers, I only manage fragments, my mind unable to hold on to what are otherwise longer, more sustained passages of world literature, language that would at least make me feel I was part of some sort of tradition. I once thought there was something wrong with me, as I had other friends who could recite long poems, passages from novels, entire acts from Shakespeare's least known plays, even pop songs. Now I interpret this failure as a virtue that's releasing me from any expectation I had of the past.

Episode 15

The Skins Game was a nightmare. I shot—biographers and literary critics, please note the use of the word, *shot*—an apocalyptic round of golf in which everything I ever had, every hope and dream, all I'd worked for, is taken from me! God I'm so bad at golf, putting on a performance ascribable to the night before. **I hadn't enough sleep**, I never have enough sleep, enough sleep can't be had, if I'd had enough sleep I would have won at least one skin! And it wasn't just that I lost, it's the way I lost, as if I was tired of the whole idea of hope or improvement, pointing to deeper, more all-encompassing psychological disturbances.

Fallen Man was there, and The Beekeeper and Jack; there were 8 of us, two foursomes, though I can't remember the others or their names, remembering names is almost too much for me now. It was a glorious day—aren't they all—the kind of day a golfer is tempted to believe he's lucky to be alive. The bigwigs were out too, we were stuck in the group right behind them.

Fallen Man teed off first, hit his drive solidly down the middle with a slight draw. Off to a good start I thought, liking Fallen Man, seeing his ball finally come to rest, always a good sign, on the left side of the fairway. Beekeeper hit next, then Jack, I can't remember where their balls ended up, I wasn't paying attention for I knew now all eyes would be on me and I don't like being watched—**I only like being watched when I hit a good shot**. Therefore I hit the ball with extreme self-consciousness, a shot that sizzled at first, as if it might have real potential, and then suddenly died in the long grass on the left side of the fairway. And this was only the beginning.

Episode 16

I keep score for our Skins Game; I suppose it was my turn, though I'm not very good at it.

I ask The Beekeeper, *What'd you get on that hole?* He says, *a 5.* I note that he answers with as few words as possible. Instead of saying, "I got a 5," he only says "5", quickly as if he doesn't want me to hear. His answer alerts something in me, its terse suddenness, his tone of voice as if he alone is

the truth and not the words that he said, so that something in me knows it isn't the score Beekeeper actually made.

I replay the hole, remember his lousy chip shot and then the 3-putt: The Beekeeper had a 7, not a 5 as he'd told me.

I don't say anything to Beekeeper, knowing he's scrupulousy duplicitous, but look at him as he's looking at me, seeing that I'm ready to enter the score he's given me on the scorecard, knowing he's lied and that he knows I know he's lied.

Wait just a minute, Beekeeper says, looking as if he's recounting his strokes to make sure he's given me the right number. *I got it wrong*, he says, *I had a 6, not a 5! I'd forgotten that lousy chip. Put me down for a 6*, he adds as if proud of himself, the most honest man in the world.

This is same day Jack says my golf book, *needs an arc.*

Jack thinks no one else is interested in what I'm interested in. *You care about what no one else cares about*, Jack says, or something along this line.

Jack can't even get a ball out of a sand trap! We all had to watch yet again, only able to see the top of his head, shovelfuls of sand being sprayed from the bunker by Jack's sand wedge with no ball appearing. I wanted to say something about *arc* in a compassionate, neoliberal tone of voice, *that he needed to change the arc of his swing or*

Museum guard and 2-handicap club champion

something similar to what he'd just said about my golf book. I said nothing, suspecting, as did Fallen Man, that Jack had finally picked up the ball and lobbed it on the green, feeling sorry for himself.

We walk up the next fairway together, Jack and I, both of us having bad golf days, the kind of day a golfer knows he can't get himself out of no matter what he does, a bottomless bottom he's stuck to until the end of the round.

It felt like Jack was holding me responsible for his failure, while I was actually thinking of how I'd brought about my own misery by not sleeping the night before, linking the memory of having very little sleep with the reality of seeing that Jack had so obviously cheated, tossing his ball out of the trap and onto the green when he thought no one was looking, and then saying nothing to any of us!

That Jack said nothing was as good as a confession; he'd definitely cheated, though he deplored cheaters, denouncing them publicly, saying cheaters should not be allowed on the golf course under any circumstance, much less be allowed to play golf.

Jack, I say the next time we play and the stench of his crime has passed, *I've played it straight and I've cheated and I've found no correlation in either case between the two.*

Cheating has actually helped my cause in the past, though I never felt good when cheating, going to great lengths not to be found out, actually hearing a voice from above, "I saw you, I know what you did, you didn't need to cheat, I was going to make things right for you on the next hole."

Though I haven't cheated at golf for many years I do give myself putts whenever possible. *This is the softly gray area of golf, giving myself putts, I say to Jack.* I know it's a form of cheating, a sin, however small—that I should never give myself a putt, whether playing for money or golfing by myself, **but I can't help it, I'm a liberal humanist**. Often I'm asked, *to putt out*—that is, those I'm playing with wish to verify by seeing that I've putted my ball into the hole whether the distance is a three inches or three feet, especially when playing for money, regardless that I've personally set a charitably reciprocal example, giving others short putts with the unspoken expectation that they will give me mine, which is the big problem with liberal humanism of course, that I'll either be understood as a sucker or *be called a socialist* or something even worse.

ROYAL CLUB 1.

8p

J. Toombs

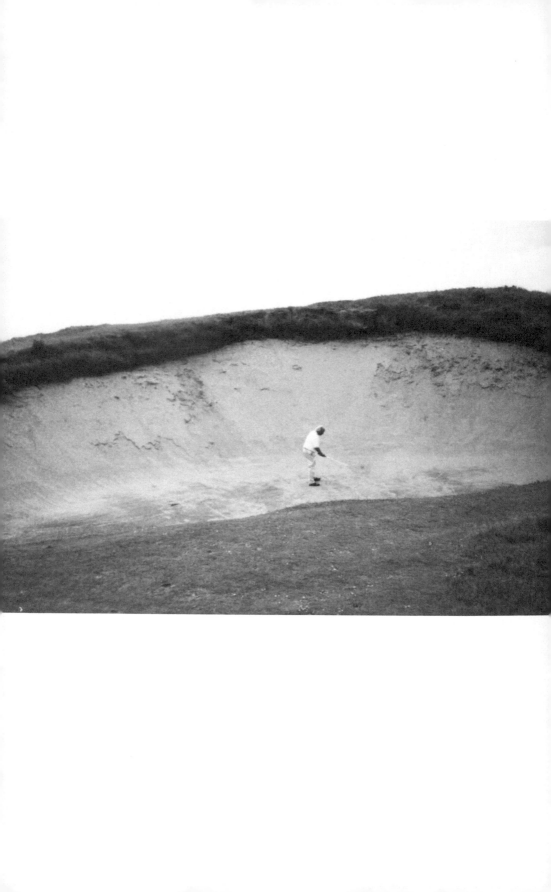

From the Skins Game forward I deteriorate into not caring or caring very little or pretending not to care about golf at all, having reached the point where I don't know what I'm doing wrong.

I really shouldn't be doing this to golf, I start to think, *golf's too great a game.* I shouldn't be thinking like this either, much less writing this stuff down. *Since taking up golf I've become obsessed with writing things down, making mental notes, counting, measuring, aiming, criticially evaluating,* and so forth...but it's just a phase, something I'm going through, I suppose.

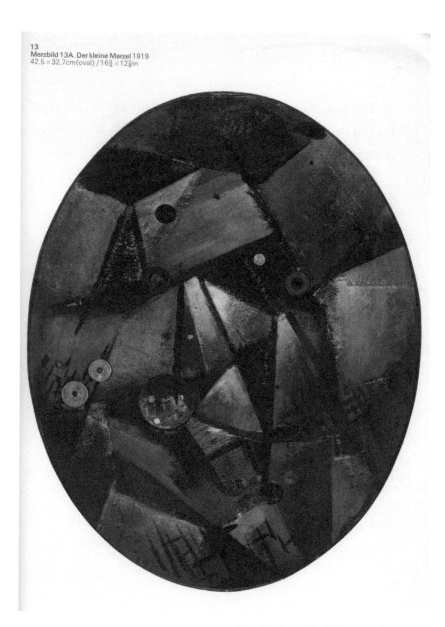

Kurt Schwitters, *Merzbild 13A. Der kleine Merzel*, 1919.

golf and the future of modern art

It's raining, I don't play golf in the rain, one should only play golf in the rain if one has no choice. That I don't play in the rain is a decision made in Ireland, long before I played golf.

At breakfast at an inn near Sligo I entered into a conversation with a Irish sportswriter close the age then I am now, who'd traveled from Dublin to cover the Irish Amateur Golf Championship.

Looking out the window all I could see was weather, a dark windy and rainy atmosphere. *There won't be any golf today*, I said to the sportswriter. *O, they'll play*, he said. We spoke a bit more, cutting our breakfast sausages and squeezing our scones dry, conversation one makes at a breakfast with guests at an Irish inn, neither of us saying anything more about the weather.

Later, driving around the countryside looking for dolmens, we passed by a golf course. There, tides of moving umbrellas—spectators and players—moved this way and that way over otherwise sodden fairways. *"O, they are playing golf!"* I said to my partner, sharing with her my earlier conversation with the sportswriter, thinking I actually saw the man himself walking, trying to keep his notes dry, ready to file a story for the Dublin newspaper the moment the tournament ended.

It's raining in San Francisco so there'll be no golf for me. I'll either have nothing to do, eat Thai food for lunch or go to the Museum of Modern Art, in that order, roughly. It's not that I eat Thai food or go to the museum every day, only on those days when it rains and I don't play golf.

I've walked these galleries many times, with or without my long black veil, so that the art has become the kind of meaningful cliché that looks and sounds new every time I see it. Many of the paintings are old acquaintances who've run out of things to say but who I'd miss if I was no longer to see them, friends in the days before I golfed, in that period of my

life when I was looking at much too much art, when looking at art was what golf would become to me, a mysteriously pleasing but curiously frustrating pastime.

I was an occasional cigarette smoker then as I am now. My brand was autobiographical, the most personal way I could think of to look at art. I specialized in contemporary American painter's who smoked—Rothko, who has several paintings in the San Francisco Museum of Modern Art recognizable enough to be instantly known as 'Rothkos', was a chain smoker of unfiltered cigarettes, as was Philip Guston. Agnes Martin lived in New Mexico without smoking, making a religion of solitude, drawing perfect pale lines of solitude on canvas after canvas. Helen Frankenthaler, as excellent a painter as I thought she was then and I think she is now, remains underrated, smoking infrequently. Richter, the German, whose book of art writing is a master work, made paintings in a large studio in Germany with as many ashtrays and assistants as Andy Warhol, a non-smoker. Knowing the biographies of these artists, who smoked and who did not, I know exactly where their paintings are located in the San Francisco Museum of Modern Art.

Episode 3

On this rainy day without golf I turn a corner in the San Francisco Museum of Modern Art led by my freckled old hand of fate itself, either in the right place at the wrong time or the wrong place at the right time, and enter a small gallery I've never entered before, drawn by a sight only I seem to be seeing, walking directly toward a small work of art hanging on a white wall all by itself.

The work is new to me, and I know it at once as both
art and golf.

The small collage is by Kurt Schwitters, born in Hanover,
Germany in 1887, 6 ½ x 4 ½ inches created in 1940, titled
Gepruft, the German word for *Inspected*.

I take a stance in front of Schwitter's collage, immediately
immersed in the glories of its compact wilderness. There's so
much happening in the small art piece that I feel as though
I could stand there at least as long or longer than I stand
before other works of art, most of them far larger.

It's while looking at the Schwitters collage that the other
art I'd taken so seriously, many of the great paintings and
sculptures of western civilization, look overblown, as if
every gesture, every brushstroke, every carving was merely
the artist's attempt to become beautiful or powerful or
immortal for as much money and therefore as much
prestige as possible.

The material contents of Schwitter's collage, titled
"Inspected", consist of three postage stamps, a short piece
of twine, an envelope, and paint on paper. I make a note that
the collage is in the museum's *Permanent Collection*.

Episode 6

Looking at Schwitters artpiece brings to mind a very nice man I once golfed with who would not or could not complete a sentence. He'd begin speaking, say a few words, most always very interesting words, then abandon whatever he was saying to either say something else or to discontinue what he'd been saying. *Did you see the sunset last night? It was truly charming*, he'd say or something equally evocative, his voice always leaving behind a faint trail of incompletion. He was not unintelligent; he was a highly educated, accomplished human being who spoke in a stream of non-sequiters.

Those of us who golfed with him exchanged theories regarding his **condition**; that he'd come to believe saying less was better than saying anything at all; he'd smoked too much marijuana at one point in his life or taken too many mushrooms as a young man; that he was poetic by nature and therefore committed to unfinished verbal projects...

What physical or psychic crisis had caused his speech pattern of serial incompletions, I wondered? Was there a triggering event? Or was it a willful social pose, a way of seeming mysterious and therefore to make him more of a person of interest to others?

Episode 7

During the time I played golf with the man who either could not or would not complete a clear declarative English sentence I became determined to understand his condition,

thinking I'd raise the issue with him during one of our golf
outings. Perhaps he was unaware of his behavior and would
be grateful for the observation. Perhaps it was a conscious
choice or an unconscious physical tic he had no control over?
I had to know!

Yet did I, really have to know?

I went back and forth for some time, obsessivly I'm now
almost ashamed to say, finally realizing that the things I
don't really need to be thinking about are often the things I
become obsessed with. I never did mention the *problem* to
him, liking the man immensely, feeling that if I did, I might
hurt his feelings or that he would feel compelled to reveal
some trauma meant to be kept private.

I long after we'd stopped playing golf together and fallen out
of one another's lives, I stumbled across the French poet's
cryptically enlightened observation that, *the only way the
sacred can protect itself is to wrap itself in mystery*, and
thought immediately of the man I played golf with who never
completed a sentence, remembering him with real fondness,
coming to see his spiritual dimension, believing it was a
purposeful mystery he was sharing with the world.

Episode 8

Jack and I discussed the meaning of such *mysteries* many
times over, never coming to any conclusion. In fact we
concluded nothing in those days; everything I discussed with
Jack always remained unconcluded…

How did golf get its name? Jack would ask every now and then, a question that continued to pester us once in awhile, each of us coming to believe there were either too many answers or none at all.

I once spent an entire morning saying the word *golf* over and over and over—**Golf Golf Golf Golf**—telling Jack that the more I said the word the more I heard in it golf's essential mystery and meaninglessness. *The meaninglessness of the word golf is absolute*, I say to Jack. The more I said the word *golf* the more I was overwhelmed by its lack of meaning. *It was like being hit by a tidal wave of unexplainable phenomena*, I say to Jack, *like the rings of Saturn or black holes* or the recently discovered scientific truth that most of the matter in the universe is invisible.

The word golf is onomatopoeic, Jack says, *conjuring up a root vegetable, a rare kind of radish or potato.*

Much more curious than the origins of the word 'golf,' Jack says, *is why there are so many fat people in this country.* Have you noticed many people are now dreadfully obese when this wasn't always the case? People were once much slimmer—you only have to look at the photographs from the time photography became an art form to *the present time.*

It's as if fatness is a kind of national destiny, Jack says. Walk into any supermarket in this country and you'll see fat people waddling down the aisles, sashaying like ducks, stuffing their shopping carts with food that isn't food, *diet this and diet that*, most of it some form of poison or another. *I'd like to ask Mr. Ben Hogan why so many people in this country are fat*, Jack says. Mr. Hogan would know, he'd tell me the truth, Jack says.

We're addicted to being unhealthy, great profits are made from our self-induced unhealthiness I say to Jack. *Doctors, psychiatrists, writers of opinion pieces in national magazines, golf journalists, seem to believe they can pinpoint the exact moment someone becomes alcoholic* or addicted to prescription drugs or a devotee of a certain political party or someone completely disinterested in politics or in golf by asking question after question. *It's as if these questions have developed an actual appetite*, I say to Jack, and that we all want more and more answers to questions that have no answers.

You might as well ask, Jack says, *when did I become a golfer? In your case a well disguised golfer*, Jack says, a golfer who does not want to look like a golfer, disliking orange shirts and blue pants, as if not wanting to fit into a stereotype.

I study Kurt Schwitters' collage from head to toe as if I'm The Inspector, **the one with the power to ask questions for the official record**: *Why am I finding this art piece so compelling?* But the answer refuses to emerge. I enlarge the question and ask again: *Why am I standing in front of this very small work of art for a much longer time than I stood before much larger, more monumental works of art just minutes ago?*

The extreme simplicity of Schwitters' collage, in contrast to my fascination with it, is in some sort of disquieting proportional imbalance: its use of common materials, objects that have otherwise outlived themselves, things thrown away—an old envelope, string, the postmark of a mailed letter, stuff saved from oblivion by an artist blessed with making a vivid present from a distant past, picking up the trash of immediate recent history and giving it new life!

I imagine Kurt Schwitters—whoever he may be—simply bending down or diving like a pelican to swoop up something that caught his eye, something others considered either garbage or a fresh anchovy. It's possible that everything Schwitters put into in the collage might have been kept at one time in the pockets of his coat and pants! Golfers too get used to keeping things in their pockets— tees, ball markers, the little gadget that fixes the dent in the green made by the impact of a golf ball, a cigarette lighter, indispensable objects they come to believe they might actually need sometime.

Jack believes the golf bag is a sacred place.

If you really want to know someone Jack once said, *look deeply into their golf bag* when they don't know you're looking. *The bag will tell you everything.* It's where the non-smoker keeps his cigarettes, matches, breath mints, and the non-drinker his flask, Jack said.

The idea that the discoverer of objects discarded by others is the true collector, and that there always comes a time when the discoverer might have forgotten what he'd found, is comforting to me and comes at a good time, a time when I was beginning to lose faith in golf, having only just begun the slow descent of forgetting everything I'd once learned about the game.

Too often now when I'm golfing I feel as if I'm taking myself to the grave, and it's not as terrible as I'd imagined, only some tree roots and the occasional trinket that might have fallen out of a dead man's pocket. And when I'm finally really deep down in there, as deep as I need to be to be fully knocked out and buried, *I wake up and see that everything's brand new, everything's fresh, and think,* **oh, so this is the gift time has given me**.

My golf bag once contained a banana I'd forgotten to eat. I'd allowed it to rot in the jungle of my bag with some small coins, wooden and plastic tees, golf balls and ball markers, a pencil and a pen, scraps of paper with phone numbers scrawled on them, old scorecards, and other artifacts I'd gathered along the way, the very things Kurt Schwitters might have used to make a collage, having once made a work of art out of the oatmeal he was served at an internment camp in England.

Jack's the first to smell it, the banana that is. *You need to find out what that smell is in your golf bag*, Jack said, remembering correctly the story I'd told him about Schwitters the other day.

Schwitters' collage: the bright snippets at the top of the collage, scissored out of some sort of German tabloid—the typeset word **FOX**, and just below it the image of a truncated lemon hanging upside down from a truncated tree—defy gravity. To the immediate right another bit of information Schwitters appropriated from a commercial publication or business venture: the name *Freia* in faded script with an orange flourish, and below that the words *Chocolate Fabrik*,

Oslo, a candy bar once manufactured in Norway. The twine hangs in a loop over the Freia cut-out, the top part of the loop resembling a noose, reaching almost to the top of the frame itself, extending downward to the middle portion of the collage, the heart of the art piece, where two symbols prod the viewer toward fuller attention.

At the bottom of Schwitters' collage are three postage stamps, officially postmarked *Hanover*. The word **Gepruft** in heavy black type, (as Gothic as Johannes Gutenberg himself, the creator of moveable type), I know instantly as German— either person, place or thing—without knowing what exactly what 'Gepruft' means: it's uber-official looking and ominously placed as if the word itself is a missile stopped in midair. I can't be sure if the word was part of the envelope itself, pre-stamped by the National Socialist government, or a Schwitters invention. In any case, the word **Gepruft** is prominent in this small collage.

The English translation of the word **Gepruft** is in fact, **Inspected**, the title Schwitters assigned his art piece.

And no doubt the personal letter which the envelope contained, presumably sent to Schwitters by his first wife Helma who'd stayed in Hanover to look after family properties, was read first by Nazi authorities.

I inspect the Schwitters collage again as if I'm walking around a beautiful city park with trees and ponds and dahlias in bloom, but with no benches, of all things, and therefore no place to sit down.

Everything about the artwork is so ordinary and small, all the visual items it contains could be considered as *cliche*, as art critics like to say. Furthermore, the San Francisco Museum of Modern Art owns the collage but only offers its name, materials of composition, dimensions, and not its provenance. *How did it come to the San Francisco Museum of Modern Art? What were the circumstances of acquisition? How much had the museum paid for the art piece?*

I inch closer to the collage, almost always standing too close to things these days, and lift my reading glasses to try to take in the details once more along with the whole, to assemble the artpiece as if I were Schwitters himself. I can see Kurt Schwitters coming up through his life as if is he's already been buried or been under water for a long time. And yet he's still hungry, hungry, hungry, his hunger is pushing him into his life, the life of an artist who knows that **all art is not only what the artist saw <u>but also what could have been seen by the artist</u>**.

If I dared, I'd put Schwitters collage into the pocket of my jacket and take it home with me.

With information gleaned from my iPhone, having Googled *Kurt Schwitters* while still standing in front of the collage, my sight travels south from the top of the collage, *Inspected*. The envelope, which constitutes the main body of the artwork, reveals in plain sight what I don't want to see— the postmark, **Oberkommando der Wehrmacht** and the **swastika**, the official Nazi birthmark.

It's as if I am seeing Schwitters' life officially coming apart right in front of my eyes. Beneath the sunny, frothy precincts of artful decoration—the orange tree with its green leaves, the package of Freia chocolate, the happy yellows and hopeful whites— is the gathering of the materials of persecution, war, and inhumanity so monstrous that not even a man with Mr. Schwitters' world-class imagination could begin to imagine.

My second impression of Schwitters' collage, noted with the blue pen I keep in my shirt pocket for special occasions and written on the stub of the general admission pass purchased at the museum entrance: *the world's a serious place and you are a small man but not that small—yet as serious as the world is, it's your responsibility to have as much fun with it as you possibly can.* I note also that I begin to look at the collage sideways, tilting my head in imitation of a Great White Egret.

Still standing in front of Schwitters' collage, looking a third and fourth time at each *object* the artist has chosen to place in his artwork, I think about the golf I could be playing and what Jack and The Beekeeper and Fallen Man, should they be playing now as I suspect they are, are saying about me?

Occasionally the museum guard walks by, hoping not to be noticed. Otherwise I'm alone in the gallery, so alone it's as if Kurt Schwitters and I are having a private conversation.

When I tell Jack I'm writing a book about golf he says, *You're a man who will be known more for his unknown writing than for what's known of his writing.* I presume you like it that way. And you know I respect your writing a great deal, at least your attempt to write that is. You're something of a poet it seems, Jack says, but you're much too self-effacing and therefore much too realistic to be a writer that other than a select few will ever read.

You seem completely unaware that *the world's actually expanded,* not contracted as so many assume, Jack says. *It's imperative you find a new way to stand out, as people are now competing for your space in all sorts of new technological forms, so that people will remember to read what you've written.*

Our world unfortunately, Jack says, *now consists of people we've never heard of and people we wished we'd never heard of, people on the front page of newspapers and on TV,* Jack says.

Forget about writing a book about golf, I say to Jack, *I've become obsessed with collage!*

If I dared to create a collage, I say to Jack, in which the many different themes, colors, truth and lies, successes and failures of my life were to be assembled to present a well-organized visual narrative, *I wouldn't know where to begin.* Like so many other people my age, my collage is a loosely organized series of experiences and events I can't talk about without either laughing or crying—family, business, poetry, art and now golf each one beautiful but never coming together in some sort of recognizable pattern.

There are only two recognizable themes in this collage of my own making, I say to Jack—**things I am naturally interested in and things I am not**, and that the distance between them makes all the difference in the world.

Golf's not a collage, golf is a woodcut, Jack says at some point—what he said exactly is in my notes somewhere, therefore this is only a simulation—*a medieval art made of spells, charms and enchantments* created by little men

who wear red and green hats made of felt and go to bed in their suspenders. *Golf's a kind of torture chamber too*, Jack said, *it's better to watch golf than to talk about it. When people talk about golf, especially the TV commentators, they almost always say the same old things, things you know they're going to say before they say them.*

Still standing in front of Schwitters' collage I submit to it in a kind of trance that's rare for me, an attention-deficit person who's been clinically diagnosed as being in hyper-conscious relationship with his surroundings, especially in public places.

Unawares, I've inched closer and closer to Kurt's collage, a world-class treasure, priceless I suspect, that is if such a designation exists in the capitalist realm, so close to it I could have caused it harm if I had that intention. Ordinarily I'm quick to resist authority but when the museum guard, a young Asian woman, taps me on the shoulder and asks me to, *please back away*, I apologize to her, having stepped over the yellow warning stripe on the museum floor meant to maintain safe distance between the object of art and its viewer.

I exit the little gallery and the Schwitters collage, embarrassed enough to feel the blood vessel on my right temple pop a wheelie, and walk up the handsome blond wooden steps toward the museum café, honoring the vow I made years ago in Paris never again to take an elevator after having been stranded in a *lift* between the 4th and 5th floors

of an old hotel in the Marais, an experience in which I was suspended in a metal cage like an industrial chicken for two hours, unable to pry the door of the cage apart with my bare hands, seeing only the webbed feet of on-lookers as they scurried about while looking upside down at me, hearing their voices for what seemed like hours until the fire brigade finally showed up, not knowing, for how could I have known, that in Paris a 17th century law requires the fire department to be on the scene in such a case. Once released by the firemen, I made a vow to never again enter a conveyance built by fallible human beings in which hidden electrical circuits are subject to mysterious breakdowns.

By the time I reach the museum café, named *Café 5* in honor of the four floors I've just climbed, I'm hungry and thirsty. It's not yet time for lunch but I feel like something's been taken out of me that needs to be replaced, that I've expended an energy unique to my experience where everything I have to give has been given to art, knowing the artist is always the one who loses the present but gains the future when the present is finally revealed to be exactly the way he or she has seen it, an exhausting exercise for both artist and art lover.

I find a seat in the café and place my order, making notes on a paper napkin while I wait for my food—

the beauty of the Schwitters, its appearance of randomness

reaction to actual conditions on the ground

& what one has on hand to respond

exiled from the country of origin

Norwegian chocolate

Loop of twine as if to tie

randomness together:

to golf is to miniaturize, to golf well is to do as little thinking
as possible

the flagstick moves in the air as if a lamp is
flickering above it

Kurt Schwitters' biography begins in Germany and ends in England with many of his world-class artworks destroyed along the way.

Raised in Hanover in some affluence, with sufficient family resources to study art at the famous Dresden Academy and therefore to have the benefit of classical European art training, Schwitters is conscripted into the 73rd Hanoverian Regiment in March 1917 but exempted for medical reasons in June of the same year. Upon reaching the unfortunate reality of having to make a living, he became a draftsman, according to the scant biographical information available, going to work at a machine factory in Wulfen, where he discovered his "**Love for the wheel, realizing that machines are abstractions of the human spirit.**" By 1918 Germany was in extreme turmoil, suffering economic,

political, and military collapse at the end of the first world war. **"What I learned at the academy was of no use to me and the useful new ideas were still unready**," Schwitters wrote of the time. **Everything had broken down and new things had to be made out of the fragments. It was like a revolution within me, not as it was, but as it should have been**."

Classically trained as a fine artist Kurt Schwitters is now classified as a *Dadaist*, the sort of man who would hit his putter out of a sand trap without asking anyone if it was a good idea, seeing it as an artistic opportunity. Key to any understanding of Dada is the realization that virtually all Dadaists, at least those of my acquaintance, are classically trained. Kurt Schwitters painted formal portraits, often on commission, to the end of his life, his subjects confident that he would not make them look like a fur tea cup, a giraffe, or a wolverine, but would make them look exactly like Schwitters saw them.

WILL'S CIGARETTES

PORTHCAWL.

WILL'S CIGARETTES.

RICHMOND PARK.
Approach to 10th Green.

WILL'S CIGARETTES.

PRESTWICK.
17th Green.

imagining a world full of
future golfers

People actually believe artists and philosophers and poets add nothing to their lives, I say to Jack the other day on the golf course, *when in truth they couldn't live without them.* Their lives would be even bleaker than they are now had there been no Immanuel Kant or Franz Schubert or John Keats or Kurt Schwitters, even though they think they have no time for them. *This is not necessarily a criticism,* I say to Jack, *this is the truth of our situation—that we've moved the future to a location no great dead poet or philosopher or artist would wish to inhabit or deign to live in.*

I don't know how poets exist in this world, Jack says, or for that matter how <u>any</u> thinking and feeling person exists, but *poets are the most vulnerable by a longshot. Poets are the great athletes of the soul,* Jack says, but they're forced to perform on smaller and smaller budgets.

The next-to-fall could very well be golfers, Jack says, it's entirely possible, don't rule it out. *Golf will soon be determined to be an endangered sport,* a frivolous pastime lorded over by wealthy patrons who appoint new commissioner after new commissioner, each of them drawing a huge salary, each ordering the draft of a new marketing plan for a multi-media ad campaign insisting on the right of golf to exist.

Platitudes will be exchanged in the free press, Jack says—
*that golf is good for you, golf is good for the youth of the
nation*, golf is good for ambitious young executives and
old people, golf gets people out into nature and so forth.
*It doesn't take long for platitudes to become propaganda
and for propaganda to become the law and what was once
an innocent game becomes big business*, Jack says, upon
which thousands, maybe millions of people depend—an
industry of groundskeepers and assistant pros and golf
club manufactuers and grill room waiters, not to mention
essentially meaningless golf competitions between the very
wealthiest continents, excluding Africa and Antartica,
Jack says.

If I ever hear a person say again, **I love golf because I love being out in nature,** *I'll be forced to take some sort of punitive legal action, I say to Jack.* **A golf course is the complete opposite of nature,** *a mechanically created, industrially fertilized, man-made contraption.*

Jack says, **well,** **a golf course is nature** *to the birds and the water and the trees,* **to everything that doesn't know the difference between what's nature and what isn't.**

After lunch in the museum café, having consumed a cup of decorative art and a cold Cobb salad with a glass of overpriced white wind, I walk back down the two flights of stairs thinking I'll look in on the Schwitters' collage again to see if my earlier reactions have or have not changed.

A group of children are standing in front of *Inspected*, no doubt out on an outing from one of the private elementary schools in San Francisco, for they all look as if they all belong to the same affluent, homogenous social caste.

A youngish woman, presumably the teacher, is reading to the children from a small pamphlet. I stand close enough to hear what she's reading, but not so close as to seem to be listening. Reading directly from the pamphlet the museum

136

may have provided or that she printed out herself at home,
she presents a picture of Schwitters as comic, a man who
finds things under the seats of buses—coins, bus tickets,
movie tokens, cigarette butts, newspapers—and makes art of
what he's found, things that have been thrown away
by others.

As the teacher reads, two of the kids, boys of course, stuff
their hands in their pants pockets, turn them inside out and
hold up what they've *found* for everyone to see—a ten-dollar
bill, some coins, earbuds to be plugged into their iPhones,
half a pack of chewing gum. They look like *Future Golfers* to
me, I think.

The young teacher keeps reading even though the children
are by now hopelessly restless, looking around at other
pictures on the walls, especially the small priceless Mondrian
nearby with its stripes of white duct tape now yellow
with age.

The schoolteacher, slightly plump but pretty in the mode of a shepherdess from the Scottish highlands, tells the children that Kurt Schwitters practiced a form of art known as *Dada*, but provides no larger context, no real history of the word *Dada*, as none was likely provided in the material she's reading from.

Episode 4

Hearing the word *Dada* the children immediately look at one another with genuine delight, certainly amused, perhaps even curious, perhaps even wanting to know more about Dada but not knowing how to ask or afraid of learning the answer. Each time the teacher reads the word *Dada* most of the children either giggle or laugh out loud.

What is this Dada? I wish the children would ask.

I'm not sure I could provide a definition of Dada if the children were to ask me, other than to say it is an art movement that began not long before World War I and is continuing to have a major influence in the lives of golfers everywhere.

Episode 5

I don't fault the children for their general disinterest—other than their delight in the word Dada, or for making it so obvious—for the teacher reads in a monotone that suggests she has very little interest in the subject herself, as if reading

is something she'd rather not be doing. She's at least aware, I think, that she'd much rather be doing something else, something she has yet to do, some sort of adventure like eating ramen noodles with her new boyfriend or girlfriend in a restaurant in Japantown.

Though the children don't know she's presenting old material—nothing not already known about Kurt Schwitters and his relatively short, tragic life, a life he did not think of as either short or tragic at all—I can't help but think they sense how extraordinary Schwitters is by the way their interest perks up everytime the word *Dada* is uttered.

Episode 6

While the teacher reads I make a note on the paper napkin from the restaurant that I'd stuffed into the right rear pocket of my pants: *I only hope that none of these children grow up to be little monsters or even worse, become men and women who know very little of their past, having no idea of what's being done in their name by the country they live in, only that which is offered in school textbooks and the occasional field trip to an art museum.*

Episode 7

Regarding the education of these little people, of which this outing to the museum is no doubt meant to play a part, I see a potential problem: I'm delighted they're in the museum but wonder if they're being colonized by their education and are being raised as the foxhunters or cricketeers or yachting

types were once raised in what were then openly imperialistic circumstances, where sport helped the privileged classes "escape the travails of civilization," in the words of the British philosopher Roger Scruton, instead of being more securely grounded in the past as the future citizens they'll soon become.

Children, I'd say to them were I their teacher, **the past is the imperialist who conspires with the colonist to create a group dedicated to their own power and wealth, having coerced its new subjects into types of like-thinking that enable the all powerful to conquer everything in its path. Beware!**

I'd also point out to the children that *Kurt Schwitters was neither rich nor poor, he was Dada, as Dada as Dada can be! Kurt Schwitters was born Dada, as we all are, for how can one who's been born NOT BE DADA?*

But I resist the urge, just as I've resisted similar urges in the past—as corrective and clarifying as an outburst might be to me or anyone else within earshot: to stand up and yell at the top of my lungs, as I did one night in an overpriced caricature of a restaurant in Los Angeles, **We're all going to die!** Not my finest moment, though very exciting at the time.

Episode 8

When the teacher and schoolchildren finally depart the small gallery, the boys running after the girls as if chasing small domesticated farm animals across an enclosed pasture in the Alps, the girls taking hardly any notice, walking at a far

more graceful, evolved pace, I stand in front of Schwitters collage, having it all to myself once again. The biography the teacher read from the pamphlet corresponds to my timeline of the artist's life without descending into the horror of war and its warping of human experience: that Kurt Schwitters biographical time frame was fractured, unsettled, a life of being separated from people and things he presumably loved—his art career and the grand Merz creations he'd made, his house in Hanover, his family—by the insane actions of supra-nationalistic powers.

Episode 9

Kurt Schwitters' wife Helma stayed behind in Hanover when he escaped to Oslo in fear of the Nazis, who were themselves busy rounding up Schwitter's fellow artists as *subversives.* In 1937, the Nazi's stage "Degenerate Art", a museum show in Munich meant to 'educate' the public on "the art of decay in modernist tendencies" such as Dada, the very sort of art Schwitters was making, actually writing in promotional materials that such art was the result of unspecified "genetic deformities and moral decadence." In 1940, the year Schwitters made the collage which I stand in front of, he moved to Oslo, Sweden, in exile with his second son, Ernst, his first son having died at the age of four in Hanover. Kurt Schwitters, Dadaist extraordinare, would never see his wife again.

Episode 10

I played golf for 12 years with a man who had two living wives, neither wife aware of the other. No one playing golf with him at the time knew about the two small bombs

he'd stashed inside his personal life—the two lives he'd hidden, one from the other. And so it's a seismic surprise to find he'd started another life in another state with another woman, that the young children he fathered in each family were completely unaware of each other, that his creation of two new familes, one of which was unknown to us, was accomplished without our knowledge and, even more astonishingly, without the knowledge of the wife and children all of us did know. It oddly felt that all of us who knew him had committed some sort of crime of our own, so that most of our own wives or girlfriends or boyfriends began to look at us very differently.

Once revealed, the news becomes privately newsworthy in our little community of like-minded people, whispered in grocery stores and at church, especially disorienting to those of us who'd spent great amounts of time with him, at least 4 hours, sometimes more, once a week, often sitting down for beer after a round of golf, though it makes the perfect sense retrospection always makes, with everything adding up to his big secret—the weekly trips to Minnesota to manage the shopping centers he said he owned there, the times he'd had to miss his children's school and sports activities because of the demands of his 'business,' and always sotto voce in a frquency that sounded like the hum of a small transistor radio of the late 1950s, scratchy enough so that you could hear but couldn't quite be sure of what he was saying; you thought you could, but you couldn't. The manner too in which he would look to his left and right after he hit a shot, furtively, as if not really wanting to see the direction his golf ball was headed, seemed strange to at least one or two of us.

It now appears this man only hoped to appear normal,
that he strove for the *look* of normality—even-tempered,
apolitical, the prototype of *the good guy*—yet also hoping to
be perceived as neutral in all things that might otherwise be
considered abnormal. His true life remained undetectable,
as if it was elsewhere, somewhere near the edge of true
interpersonal interaction but never within its sphere.

I wonder, *when was the exact moment my ex-friend had
decided to live two lives and keep both secret? Was his love
for both his wives equal? Did each of the women give him
something the other did not?* These questions came to me
at odd, unbidden moments, long after I'd lost touch with
him, well after his secret life was revealed, never seeing this
man again, for he moved out of the community overnight,
presumably returning to the life in Minnesota that we who
knew him knew nothing about.

I tell Jack—he loves a good story—about my friend with
two wives, providing as much context as I can of this man's
duplicity, trying to fill in the blanks of a lie so massive that
it was two lies inside of one, or one old lie expanded into a
multitude of new lies, each lie requiring its own logistical arc,
just like propaganda. I try to draw paralells to the ways golf
too keeps setting impossibly false standards which the golfer

believes he has to live up to, often becoming a project he abandons but is preoccupied with the rest of his life.

I once believed, I say to Jack, *that on the golf course everyone becomes who they really are. But I now have proof that the golfer is also able to keep who he really is to himself,* especially when it's to his benefit. *I'm also acutely aware of liars now,* I say to Jack, it puzzles me that so many liars are rich, rich beyond any possibility of spending one-one hundreth of their wealth before they die. *Golfers it seems have a great need to think they're better golfers than they really are* and need others to think so too and so, having hit a ball so deeply into the woods it can only be lost, miraculously find their lost ball and in a much better place than anyone could have imagined, so often in such a favorable place that *the rich man actually has a shot at the green, a shot the rest of us would never have had.*

Maybe the rich are just lucky, Jack says, *for you've got to be lucky to have a good life and to be rich.* I'm surprised that Jack's saying this, as Jack has a good life though he often claims he's never been lucky, that whatever he's achieved he's achieved without luck. *If I hit a shot in the same place that you hit a shot,* Jack says, *my shot will bounce left into the sand trap and yours will bounce right, safely toward the green.*

I like Jack enough to be on the lookout to see if what he
says is true—that I'm lucky and he unlucky—and can say with
certainty now, over the course of playing golf with him for
years, that I am unlucky just as often as he is lucky. And
I say so.

Did you see how lucky your ball was on the 4th hole today,
I say to Jack, *where it bounced right to avoid the out-of-
bounds and how unlucky my ball was, bouncing left into
the hazard…*

Jack seems to be in love with his bad luck? I hope to tell him
the truth some day—*that bad luck is bound to happen at
least once or twice a round, that once is understandable,
twice is tolerable, but the third time is the kind of bad luck
only the golfer who hit the shot would ever have*—but today
isn't the right day. The subject of luck is not a rational subject;
it's better to say nothing at all to Jack about luck, particularly
the truth. Jack will not be persuaded that all the bad luck
belongs to him and all the good luck to me and to others.

It's just my luck then, though whether it's luck or not luck is
not the point, that Jack, having missed me on the golf course
the day I visit the museum, asks me the next time we meet to
tell him about Kurt Schwitters who he's never heard of.

Give me the executive summary, Jack says.

Schwitters is a poet I say, *and to write a poem you have to have all the good luck in the world* which is why so many good poets are so poor, having given all their good luck to their poems. *To be a poet you have to be as lucky as Kurt Schwitters* whose poem, *An Anna Blume,* is still recited by schoolchildren in Germany.

But Jack isn't listening, he's only pretending to listen, so I discontinue my answer to his question.

Kurt Schwitters: *lucky* or *unlucky*? Many of his greatest art creations destroyed by forces outside his control; his youngest son, dead at the age of 4; his family torn apart, his career, if he ever thought in terms of a 'career' that is, ruined beyond any imagination other than Kurt Schwitters', not yet knowing his life was coming to an end in a foreign country.

All I manage to tell Jack *is that there's no evidence that Schwitters believed in luck or did not,* though there's no doubt he would have enjoyed hearing himself called *lucky* as much as he would have enjoyed hearing someone call him *happy,* or by making someone laugh. *Luck isn't bestowed, it's the way the ball bounces,* I say to Jack.

Upon further consideration, (i.e.what I should have said): how one thinks about luck makes one lucky or not lucky. **It seems that over time luck is either conferred or not conferred until you come to think of youself as either a lucky person or an unlucky person and are seen as such by others.** Chance is a different sort of luck, speculative, self-imposed. You take a chance but you don't take luck; luck takes you wherever it wants. There's always a chance of luck, but rarely the luck of chance.

Luck is the black sheep of predetermination, I also think of saying to Jack but don't. Not having thought to say it at the time, I feel it's best to say it later

Episode 18

Imagining how Kurt Schwitters might have reacted to what can only be called *bad luck*, I imagine he was thrilled as much with destruction as he was with creation.

Episode 19

The day after I share the story of 'The Man Who Had Two Wives' with Jack he says, *human beings love puzzles, people will stay up almost all night trying to solve puzzles. This collective love of puzzles has brought us to this point, the point where the world can now be divided into people who wear hats and people who don't. It's that primal.* There's a whole tribe of hat wearers now, Jack says, and a sub-tribe of men who wear their hats backwards with the brim in the rear.

Nothing makes sense of what Jack's just said—it might seem as if it makes sense but it doesn't. It sounds like the famous American painter saying of his art that he 'tried to keep the paint as good as it was in the can', a form of nonsense endemic to the world of art.

Little, if not nothing, makes sense of Kurt Schwitters' life; the early death of his first son, (he keeps the death mask he's made of the infant to the end of his own life); political exile with his second son Ernst (without his wife, Helma); his poem "An Anna Blume" becoming an international sensation; his work denounced as "degenerate" by the Nazi's; his fantastic creation *The Merzbau,* an art piece constructed from the rooms of his own home in Hanover, destroyed by Allied bombing in 1944; the fact that an uncashed check from the Metropolitan Museum of Modern Art was found in the pocket of his pants when he died in England of all places in 1948.

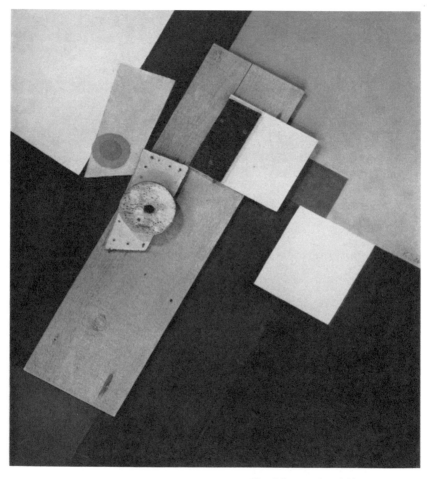

Kurt Schwitters, *Merzbild mit grünem
Ring*, 1926

"my name is Kurt Schwitters and
I nail my pictures together"

Let me count the ways Kurt Schwitters is a great man, living a life filled with scenes from which an epic movie deserves to be made.

An hour or so into the film Schwitters is being questioned by Nazi's who classify him as a practitioner of **degenerate art**, reportedly without having seen his art, fearful, it would seem, that Schwitter's art either meant nothing to them or had a meaning they couldn't understand.

What questions did Nazis ask Herr Schwitters in 1939? Questions that must have so unnerved him that he moved from his home in Hanover—an established world-class artist-poet, a constructor of major installations, painter, collagist, creator of an movement called **Merz**, with a growing international reputation—to Oslo, Norway, leaving his wife in Germany to manage the properties the family depended on for income.

They must not have been questions at all the Nazis asked Schwitters, as tyrants everywhere operate by three-prongs: **innuendo**, **accusation**, **inquisition**, the usual time-tested tyrannical tactics.

Did Schwitters think of negotiating with the Nazis? He was certainly intelligent enough to realize negotiation might have been the only way out—i.e. **death by negotiation**. It is possible, at least for the purpose of cinematic art, to believe Nazis were dazzled by the imagination and intelligence of Schwitters, perhaps finding him slightly eccentric, just eccentric enough to roll their eyes, but essentially harmless,

Kurt Schwitters, artist, 1887-1948

an artist after all. But why make life so uncomfortable for him that he would have no other choice but to flee to a foreign country? Why not instead give Schwitters a drafting table and the assignment of designing a championship 18-hole golf course in the Black Forest, where officers of The National Socialist Worker's Party could play at their leisure?

What might have it been like to play a round of golf with Kurt Schwitters? A Dadaist who'd rather not draw attention to himself but rather toward something he'd made by himself; a man I'd want to play golf with; a man named Kurt who enjoyed making others laugh, as long as he laughed first, not worrying that others might be laughing at him, able to listen as others laughed at what he'd said.

It's quite possible to imagine a golfer introducing himself on the 1st tee: "**Hello, my name is Kurt Schwitters...I am an artist and I nail my pictures together**," something Kurt Schwitters said.

Todd, a man I've played golf with, is a Nazi. I know he's Nazi because he always acts like he's never met me no matter how many times we've played golf together. Todd always said one of three things the three times I played with him.

1) *I know you, don't I?*
2) *Haven't we run in to each other somewhere before?*
3) *You look so familiar*!

The fourth and final time I played with Todd I saw he had no self, that he'd given whatever self he had to something else for a cause I'd never understand. Todd could actually pretend to look at you and either see nothing there or pretend he was seeing nothing there. The ability to only see himself gave Todd a strange confidence, but it was only a gray uniform he was wearing. And Todd had a terrible temper, the kind of temper only a man who never wants to be seen as out of control has, a sudden rage, both existing and coming out of nowhere like a bullet or a grenade or some sort of nerve-gas.

The moment after one of his explosions, Todd would behave as if nothing out of the ordinary had happened. He'd smile and say something nice, coming as close as he could humanly come to an apology without confessing his sin.

I made every effort as a golfer to understand Todd, coming to understand that everything I'd heard about Freudian psychotherapy had come to life within him—a man who repressed all the 759 uninvestigated parts of his life that were gurgling uncontrollably within him.

I began to feel extremely sympathetic toward him as a person, drawing me inexplicably closer and closer to Todd, so close that I became sorry to be seeing the things I was seeing and hearing the things I was hearing from him while at the same time never wanting to see him again, believing that Todd quite literally didn't know what he was doing.

Todd it seems was what the Nazis themselves after the war liked to call "a good Nazi."

Golf often makes normal people weird and weird people normal. I know men who are only happy on the golf course, actually believing that if you were to take golf away from them they would be miserable. If these men could not play golf their lives would mean even less than they already seem to believe their lives mean. So many of them are quite gifted too, men who can recall every hole they've played, every shot they've hit, able to discuss their golf in great detail.

Back inside the little gallery with Kurt Schwitters once again—having briefly followed two people I imagine as golfers, trying to see things as they were seeing them, watching them drift into the big gallery consecrated to abstract art—I spend another fifteen minutes looking at *Inspected,* the time it takes to successfully play the average hole of golf.

Schwitters was epileptic. Now knowing this, I look at *Inspected* with even more earnest discombobulation. I can find no records detailing Schwitters' medical condition at the time he was at the height of his power, or later when he was in exile in Norway and England. Schwitters' personal situation certainly qualifies as being, *unbearable*: hounded out of his native country by a pack of werewolves in the prime of his life, separated from his wife who he'd see once more or never again according to two different biographers, taking up residence in a foreign country that would soon be invaded by the very regime that had banished him in the first place. **And yet Schwitters made art and lived his life as if he couldn't get enough reality**, **as if war and exile were actually to his benefit**.

Miraculously, or so it seems in the nearly unanimous judgement of art historians, Schwitters was able to personally transform an ugly swath of history that is otherwise relentlessly barbaric into a patchwork of mostly joyful creative episodes, in which various means of artistic investigation and

production were employed to create whole new worlds of art expression between falling bombs and momentarily clear skies.

Kurt Schwitters was that extremely rare human being who not only accepted reality but embraced it. It's Schwitters who said of what he was up to: "**A game played with serious problems. That's what art is**."

Suddenly I'm weary with the weariness specific to aftermaths, having eaten a large meal with a glass of good wine at lunch and then returning directly to the wee gallery and its Schwitters collage.

Suddenly weary from looking at too much art, no longer seeing the Schwitters collage the way it wants to be seen, I exit the gallery and find a bench to sit down on beside a gallery devoted to photography. For at least ten minutes I watch other art visitors wander in and out of other galleries, then emerging looking as if they'd made the art themselves, their talk livelier than it had been before lunch.

The sounds they're making are lively enough to make me believe they'd foregone the lunch I'd eaten in order to be on the receiving end of an energy not so weighed down by the past.

Then, for a few moments of heightened cliché, everyone and everything in the museum looks and sounds to be in some sort of actual humanistic harmony. **Time stops being time, a cliché perhaps but apt as a cliché always is, as time so often stops being time on a golf course.** Sitting on the bench, watching people wander from gallery to gallery, I remember once overhearing an astrophysicist say on TV, *There's no scientific proof that time exists*, thinking I knew exactly what he meant, though now I'm not sure. What the astrophysicist meant is probably more a feeling than a thought.

Alone, with no Jack to bounce myself off of, it remains a ground-level mystery to me, particularly from the perspective of the wooden bench on which I sit, **how golf became important in my life, that I've come to care about things I've never cared about, largely inconsequential things that would not have received my attention otherwise—** the slope of a green, the placement of the bunkers and the quality of the sand in them, the differences between driver and 7-iron, the nuances in the meaning of the words, *happiness, joy, remorse, regret.*

At some point I see that the object of golf is placed behind or under things and that often the object itself tries to get out from under what it's placed behind, another object which

may or may not have moved itself in order to become an obstacle—a tree whose branches are blowing in the wind, a major gouge left by another golfer on the surface of the otherwise smooth grass upon which my ball has landed, or the many other small but significant catastrophes that were pre-packaged for me.

In golf everything is a frontier, even the shortest distance from here to there, much like Dada.

Episode 14

Sitting, I consider Dada again and again. Dada pesters me. The best I can do is to define Dada as the act of retrieving what's been lost and making something entirely new of it. Dada is what happens to a golf ball, a ball hit so deep into the woods or into the water, another one of the *hazards* common to a golf course, that there's no point in looking for it, and from that point there's only the project of going on, of making a fresh start out of a very old ending. Thinking of Dada I also vow to begin loving my fate, whatever it might become.

Episode 15

As if in a collage of my own creation, sitting on a bench inside the San Francisco Museum of Modern Art, I assemble my golf biography, finding bits and pieces of it here and there like driftwood on the little beach of my memory, some making sense and some making no sense at all.

I begin meeting people on the golf course I actually like and who like me, playing mostly with Roger and Misty, husband and wife: Roger's at least 30 years older than Misty, and both are good players. I wasn't yet a good player, nor would I ever reliably be as I was only then just beginning to become interested in the game enough to think that someday I might enjoy playing golf.

You're a good golfer, Roger liked to say when I hit more bad shots than good, in a tone of voice that was taking golf very lightly.

The first time we played, somewhere on the front 9 (the *front 9* being the first of a total of 18 holes, *the back 9* being holes 10-18) Roger said to me, *You know what they say about golf?*

No, I said, *I do not.*

Can't wait to get on the course, can't wait to get off, Roger said, winking as if he'd told me a joke.

By the third hole, after I'd made par on Holes 1 and 2 and was feeling good about myself, thinking I might have a real feel for the sport, Roger propositioned me.

You're a good golfer, Roger said, *Why don't we play a little game?*

Roger proposed the terms: I'd play from the back tees because I was such a good golfer and he'd play from the senior tees because he was the senior and the senior tees were much closer the hole. $15 a hole, with 'carry-overs' he called them, a term of golf gambling with which I was not yet familiar.

I begin well, winning the first two holes, holes #3 and 4, listening to Roger say more than once after I hit a good shot, *You're a good golfer.* I don't win another hole after #5. Roger one-putted almost every green, chipped in from off the green at least twice. He couldn't drive the ball very far, but his ball-flight was always straight, as opposed to mine, often in the rough or worse, out of bounds. Roger won 12 holes to my 2; I owed him over $150.00, once a great deal of money. He shook my hand and said, *Meet me in the clubhouse and I'll buy you a drink.*

When I arrive at the clubhouse Roger was already there with Misty, his young wife. *What would you like to drink?* Roger asked. *I'm buying. Champagne? Get a bottle if you'd like, Misty likes champagne."*

I'll have a martini, I said, *just like yours*. Roger looked pleased and ordered for us both.

That was a great match, Roger said when the drinks came. *You liked it*, I said, *because you won*. Roger laughed. *You're a good golfer*, he said, ordering another martini and a bottle of champagne.

I have to say, Roger said, *that today was one of the greatest days of my life.*

I found out later that a lawsuit Roger had filed against an airline had been settled in court that morning, and that he'd driven directly to the golf course with a settlement for $200 million.

Episode 19

I miss Roger not being in the world any longer, even though he trounced me, a person who when I first started playing meant so much to me, who had so much unself-conscious fun on the golf course. Nothing was serious enough for Roger to take seriously.

He told me that he'd once argued in a court of law *that there were too many lawyers in the world*, citing the imbalance of the lawyer-to-citizen ratio that led to the downfall of Rome, and lost the case in the process. A chubby unathletic man with white hair and red cheeks and no ego showing, Roger always wore a blue shirt with some sort of flower printed on it. I think it was always the same blue shirt, but I can't be sure, only that it looked like the same shirt to me.

When I tell the Roger story to Jack, he says, *now I understand why you don't like to gamble on the golf course. Losing was a negative first experience for you*, a primal golf event that left scars. It says something positive that you've maintained such a high regard for Roger, who clearly hustled you and took your money, Jack says.

I attended Roger's memorial, I say to Jack. *The pastor gave a little speech in which the Roger I knew was unrecognizable, calling him a good Christian*, which all of us who knew him knew was unquestionably untrue, making Roger's life sound so full of goodness that it couldn't have been better, one cliché after another, I say to Jack. I spoke, too I couldn't help it, I rose to my feet, possessed I suppose by fears of my own death, and said something about golf, *that golf forces you to look upside down at things, that when you're playing well golf is a kind of heaven and when you're playing poorly you begin to believe there's something worthwhile about death*, and *that Roger always had fun, that he never took golf seriously as if golf was der Fuhrer.*

That's all I remember saying at Roger's memorial, I say to Jack, though I'll never forget the big silence when I stopped speaking, as if people had actually been listening.

There was a reception after the service—now there's an art concept for you, a reception for a dead man—I say to Jack. Open bar. Champagne, martini's, good scotch, every imaginable alcohol. All his so-called golf friends from the club were there. They passed a hat for some sort of junior golf foundation they said Roger was *"excited"* about, I say to Jack, all these old guys writing checks, throwing hundred dollar bills into a hat, emptying their consciences, as far as I could see. *Sometimes I think there's nothing worse than these guys, who are by the way, all good guys.*

I wish I could put it into words, I say to Jack, so many of these good guys are borderline *unhappy almost to a man* unless they're playing golf, so miserable they have to start foundations, programs, institutes to pass along their misery in the hope that the beneficiaries will escape the misery they're happy to pass along, pleased with themselves that they're doing so much good for others.

A year or so after my introduction to Roger and Misty, beginning to play golf with others as much or more than playing alone, I join a local golf club, witnessing a scene that seems to have been staged especially for my benefit.

As a new member I'm encouraged to use the club for entertainment and suggest to an associate that he meet me there for lunch. We meet at noon, deciding to eat in the men's grill, *the casual alternative,* as they liked to call it, to the more formal dining room.

While waiting to be served I watch the bartender pour drinks and arrange them in a very precise, pre-determined order on the bar, as if he was lining up toy soldiers for a military campaign. The drinks are encyclopedic—clear liquids I presumed to be vodka or gin, dark beers and lagers, red and white wines, amber scotch and/or bourbon glittering away in their glasses. I count twelve apostolic vessels, each filled with a different spirit.

At precisely 12:05 pm, not a second before, a bedraggled troop of twelve older men walked into the grillroom, golfers, each of them grim in their own tired way. The drinks on the bar counter were theirs, the bartender knowing what drink each man preferred, the reward for the round of golf they'd just played.

What I first noticed about these men was the mismatch between the pleasantness of their immediate surroundings and their more-or-less uniformly unexpressive reactions to it, which I, in my innocence as a new member, interpreted as a paean to Greek stoicism. And that they were all of about the same age, considerably older than I was then.

I've never seen a group portrait of such visual unhappiness before or since—it was something out of Rembrandt or Frans Hals. There was no one in particular I noticed, there was rather a collection of forlorn male samenesses, as though every man had spent an intense four hours examining his life under klieg lights, just returned from the enemy battlefield for a slight refreshment and water for the horse before being sent out to the enemy once again, finally deciding that they wanted to be just like each other. Perhaps the sight was enhanced by its context—a nicely appointed grillroom, a bartender who knew the men by name and had arranged their beverages accordingly, the reward for having completed a round of golf while other people were working.

This sepulchral scene occurred at a time when I hardly had time to play golf on a Saturday or a Sunday much less a week day. *Why, having achieved two things I thought I wanted at the time—free time and money—did these men look so unhappy?* Transfixed, I stared at them, I couldn't help myself: every face looked as if something in their lives was out of place or altogether missing. Why weren't they beaming, as I

would have beamed, with their good fortune? Why did they instead look like some sort of form of boxed-up breakfast cereal with arms and legs? And though the sound of their conversations did increase with their second or third drink, it never reached the level of high spirits one would expect to hear among men who had every reason to be happy.

I continued to watch these men as they drank their beverages of choice and ate delicious-looking plates of food brought to them by waiters who knew their names and treated them with attentive consideration. It seemed they were eating and drinking so prolifically that they were growing new stomachs to accommodate their prodigious intake right in front of my eyes!

Perhaps they weren't feeling well or that feeling good was foreign to them, Jack said when I told him my little story, *perhaps they'd reached the age when ailments became more common* and discussions often center around stomach problems, sore feet, aching knees and hips.

Or perhaps they'd been put in the position of doing what they wanted to do, having that kind of freedom, by someone other than themselves and resented it as one would any imposition, Jack said.

The disparity between the luxury of the surroundings and their apparent displeasure with it—why no smiles of contentment, no real laughter—was so curious to me, I said to Jack. Not only were these men not really enjoying what they were doing, it was as if they were watching any future they might actually enjoy being erased right in front of their eyes. They acted, individually and as a group, as if instead of something wonderful being given to them something even more wonderful was being taken away! I wondered if they'd ever been happy, noticing that many of them had the breasts of little girls beginning to become teenagers, and that they all wore golf shirts emblazoned with the logos of prestigious golf clubs they'd either played or belonged to.

After seeing these men around the club a second and third time, I say to Jack, always wearing the same sort of sullen countenance I'd seen that day in the grillroom, *I thought they must be men who were born this way, that their way of being in the world had become a habit,* that they'd settled into a phase of their lives when any expression of real joy was impossible.

I vowed not to let myself become one of these men when the time came. Then some years later, becoming their age, the age I am now, I understood something about them I hadn't understood before: they were men who could not accept that they had all they could ever hope to have, having little or no imagination they knew they simply couldn't make their lives any bigger than they already were.

道法自然

you discover
who you are
by acting naturally

the answer to everything is
Japanese poetry

Jack and I make an agreement: <u>never to ask what someone does for a living</u>, or to ever call another man 'a great guy' or a 'good guy' especially in their presence.

If a person new to you asks you on the first tee, **what do you do for a living?** Jack says, *that person is to be automatically distrusted,* someone to never play golf with again. Jack's adamant on this point.

Invariably the person who insists on knowing what you do for a living as the first point of contact does so in hopes of you asking what he does for a living, having a better position than you. He soon reveals other unlikable aspects of his character, Jack says—talking about famous people he 'knows', how much money he makes, giving himself increasingly longer putts, saying things like "there you go, kiddo" or some other demeaning condescension just after you've finally hit a decent shot yourself. Jack says.

Asking what someone does for a living while on the golf course is disrespectful to the game of golf, Jack says. Asking someone their name, Jack says, is the right thing to do, asking what they'd like to be called is respectful and a natural part of golf protocol, but *it's a terrible mistake to ask someone what they do for a living* as if what they do for a living is what defines them.

And there are no 'great guys' anymore, Jack says, as you indicated previously.

No, there are no great guys, I say to Jack.

There might have been great guys at one time but now there are only good guys who play golf. *A good guy agrees with you most of the time,* I say, you think of him as good because he confirms what you already admire in yourself. He praises your good shots and acts appropriately on your bad shots by either saying nothing as if he hadn't noticed or saying something like, "That's a good miss" or "You can still get that up and down for par."

A good guy's relationship with another good guy is based on the neo-liberal socio-economic model, I say. Good guys are lawyers, orthopedic surgeons, salesmen of high-grade aluminum siding, shrewd businessmen, pastors surrounded by their squad of true believers. *Good guys do charity work and gamble and drink freely, but in apparent moderation;* the more charity work they do and the more piety they outwardly express, the more they gamble and drink. *Some guys are born good guys and can't help themselves, it's just the way they are,* I say to Jack.

I know good guys who've never lost a golf ball, Jack says. No matter how far they hit their ball into the forest or into the water they always find their balls, Jack says. These good

guys are also often good fathers, leaders of money-making corporations, good men respected in the community and so forth.

A man reported to be a billionaire I golfed with once hit his ball far right, near or over the out-of-bounds stakes, Jack says. I suggested he hit a *provisional* ball, customary golf protocol. "No need to," he said, sure he'd find his ball, having never hit a golf ball out of bounds before. We drove the cart along the path toward where he knew his ball was, but no ball could be seen. He then reached into his left pocket, found his auxiliary ball and dropped it when he thought I wasn't looking. "Here it is," he said, "I knew it wasn't out of bounds," Jack says. *The guy was a billionaire, Jack says, who always complained about being hounded by the government for not paying his taxes.*

There was a great guy once, I say to Jack, a Japanese poet named Ryokan. *I've memorized one of his poems.*

I say the poem to Jack, knowing it by heart—

> **My poems are not poems**
> **And when you understand that my poems are not poems**
> **Then we can talk about poetry**

I like the sound of it, Jack says, *though I'm not sure what it means.*

I don't think we're meant to know what it means, I say to Jack. The meaning is all in the feeling.

Everything has to mean something, Jack says.

I suppose you're right, I say, *I suppose Ryokan means golf is full of characters* who don't really think much about what they're doing but don't know what else to do. They're either having fun or trying to live up to some ideal that's either worth living up to or isn't. But that's only a guess.

*The Ryokan poem is negative and positive in its extreme*s, Jack says. *It's like someone talking in my backswing*—I may not know what they're saying but the sound of their voice is more than enough to get my attention.

LONGDOGS ··· BILLBURGERS
SOFT DRINKS ··· COFFEE
· NOVELITIES ·

7x12--$1450

Bill's Burger Shack

turning before the turn

Jack's not well. Something's wrong, but he won't talk of it. He's become increasingly unbalanced, the type of person who doesn't care who he plays golf with.

I don't like my name anymore, Jack said the other day, *in fact I'm very sorry it's my name.* Then he says he'd looked at Kurt Schwitters' art on-line and found it *artless and disturbing, as disturbing as the name Schwitters. The music of his name is an untenable sound, it sounds like a golf ball dropping into the wrong hole. My own name does me no favor either—who on earth would want to be called 'Jack?' I'll spend the rest of my life in search of a new name, a name I like hearing others say,* Jack says.

Jack then tells me the book on golf will never get written if I keep looking at Schwitters art. *He'll deter you,* Jack says, *Schwitters is that kind of personality,* there's not a potato chip of light in his work, not a wink of love. *This Schwitters is a frivolous character,* one of the most privileged artists in history, a complete and utter beneficiary of the system you're so suspicious of.

Your fascination with Schwitters is affecting your golf too, Jack says, you can't see it, you'll be the last person to see it, but I see it, I see it very clearly. Schwitters has given you the equivalent of the shanks and the yips. *You'll never figure out the puzzle Schwitters presents, it's a maze of dank uninhabited places* you keep walking toward like you're looking for something! *There's nothing to look for*, Jack says, *nothing, and that's the point*!

I look Jack from head to toe. I can see he's darkened a little, he's dank too, and somewhat shrunken it seems, apparently having come to a pausing point where he believes nothing good will ever happen in his life again. He also suffers from a mild case of 2nd degree crenallation around the tops and bottoms on both his knees, often the onset of some more serious withering. And there's a spot under his right eye that looks like a piece of dead wood. Jack appears as if his life might be too much for him at the moment, that he considers his human experience as an bothersome form of nonsense. There's no moaning though, Jack wouldn't be caught dead in a moan, he's not a moaner, he's far too vain. You can spot Jack's vanity from 200 yards, he can't hide it, the horns of Jack's vanity stick up straight out of the top of his head, his vanity is why he won't wear a hat for more than an hour at a time, if he wore a hat at all.

Jack deeply believed the sun couldn't get to him no matter how much he was out in the sun. He was born into a world of self-made men—Jack's father was self-made as was his father's father and his great-great grandfather, and so on and so on to the beginning of time it seems—bred to be

completely free self-made men and to stay that way, full of self-made pride, men who valued financial independence at any price.

I'll never have as many golf shirts as Jack; his closet is psychedelic with golf shirts, golf belts, pants, shoes, golf sweaters, jackets. *I never wear the same thing twice*, Jack loved to say, though I wonder now if he really loved saying it or if it was simply another of his vanities.

Something's creeped into Jack, he looks like he's changing for better and worse, that he might be struggling under the influence of more than a few clichés.

Then one day out of nowhere Jack says—**I've never been understood!**

I can't belive I heard what you said just now, I say to Jack! You of all people employing the cliché, '**I've never been understood**'. *Did you really say that?* I ask Jack.

The longest silence Jack's ever presented me now stands up to its full height, 5 ft. 10 inches, as the most thunderous cliché uttered—**never being understood**, and saying so out loud.

Standing in the puddle of silence Jack's made, a fairly large puddle of standing water, I finally see that we're natural opponents, Jack and I, with contrary life philosophies and values and human natures that will ultimately keep us apart. He's overweight, I'm under. Jack opposes me no matter what I say, whatever the issue is he takes the other side, as if opposition was a sign of his intelligence.

When we golfed together he made sure we were always on different teams. **Only golf could have united us**. We had nothing else in common. When I said to him, *To play golf is to walk through the museum you've made of yourself*, he didn't know what I meant, nor did he care.

One day apropos of nothing, to test the waters among a 4-some I was new to, I say out loud, *Our leaders are war criminals.* Jack turned his back on me. He couldn't have cared less about the empire he'd been so proud to help create, not that he really believed the empire was built on Christian faith and good works and not the poverty of slaves, but that he so desperately wanted to believe that women, not men, were the real enemy. Jack was politically irresponsible too, and acted at all times as if he expected a limousine to show up the moment he walked off the golf course.

Episode 7

Golf's turned me into a person I'd never be had I never played, Jack says, stretching to reach the top of the door of the silence between us. *Part of that person I admire*—a good driver of the golf ball, the man who can play a bump and run shot almost professionally, who's taught himself to use his hybrid club to both chip and putt with when he's just off the green—and part of that person I loathe.

Have you been looking at Kurt Schwitters? I say to Jack, but get no answer.

Episode 8

Jack, we need to go see Gregor, we need to play golf with Gregor. You'll understand Schwitters when you play golf with Gregor. *I can set it up, I can make it happen*, I say to Jack. I

184

say, no problem, I belong to the club. It doesn't matter what we score, *we won't keep track of our shots, we'll just hit golf balls until we're both happy.*

I make a note to show Jack the last letter Kurt Schwitters wrote to his wife, April 1941, sent from the Isle of Man to Hanover, Germany where she was still living: "***I am now the last artist here—all others are free. But all things are equal. If I stay here, then I have plenty to occupy myself. If I manage to leave, then I will be somewhere else. You carry your own joy with you wherever you go.***"

Gregor, 86, nearly dead when I meet him, who'll only die when he knows he's exhausted his life, that sort of man, Is the richest man I'll ever know, so rich he has no need to show his wealth, a man I instantly admire.

When Gregor spills a drop or two of coffee on his shirt on his way to the golf course, the drops are still there when he gets to the first tee. Shirts were shirts, pants were pants, shoes were shoes to Gregor—everything he wore had been worn many times before. Gregor un-monetized everything he touched. A walker, Gregor pushes an push-cart purchased at the Goodwill thrift shop for $3. Gregor loves saying the words, "3 dollars" and "Goodwill", knowing how rare good

will is. Never more than 9-clubs in the bag—driver, 3-wood 5-iron, 7-iron, 8-iron, 3 wedges, and putter—and sometimes less.

Gregor's golf is both creative and procedural: he hits his shot and wheels his push-cart near where the ball rests, retrieves from his golf bag a cut-down 2x4 to which he's attached another piece of wood with a big brass nail on the bottom; his "throne." Gregor screws the nail into the turf and sits for a moment or two, catching his breath before he hits the next shot. Gregor putts once and only once. If the ball comes to rest 6-feet from the hole, as it often does as Gregor is a lousy putter, he picks up his ball and says, *That's good*. It didn't matter at all to Gregor how others saw him, there wasn't a trace of self-consciousness anywhere near him, his life was all on-going.

Episode 11

Shortly after golfing with Gregor, always accidental, never planned, we just happen to show up at the same time in the late evenings without knowing either of us would be there, I take a look at myself and **see there are two paths I might take—the path still in front of me and the path I've left behind**.

Episode 12

I still don't have an identity as a golfer, rather my identity is always in the crisis of its development: I'm good one day, decent the next, and abominable the day after that.

Do I actually look like a golfer? I take a little practice look, then another. The orange shirt and the blue pants look almost like me, that I'm almost ready to fit a stereotype, though some of my golf shirts look like they're hundred years old. I've washed and dried them forever and they still perform like professionals—perhaps they're made out of some fabric imported from the moon! Most of my golf clothes were bequeathed me by Jack, via his young widow. Jack had an amazing golf life, everyone who knew him would agree. Golf meant the world to him, he lived for golf. Jack knew how to play in the rain too, he grew up playing golf in the rain.

Jack and I get into it the last time we golf, a nasty little exchange I now regret, had I known then what would happen next. The question arose—**is it grammatically correct to use the word very in the phrase 'very unique?'**

Jack says something is *very unique* habitually; I say something is either unique or it isn't, knowing I'm correct, that uniqueness is singular, not requiring the adjective. Jack, however, is aggrieved.

I'm getting so tired of trying to understand things, he says, I'm on the cusp of exhaustion trying to understand what can't be understood. *I can see that the rest of my life will be lived in one form of pain management or another.*

Episode 13

I start to feel sorry for Jack but stop, as feeling sorry for someone else is also a way of feeling sorry for myself.

I don't know what to say, I say to Jack, wanting to say something that might be meaningful but not having anything to say on that score. Jack's worked hard at being a good character, almost to the very end of this book, and deserves much better. Not knowing what to say, however, it's better to say nothing so that his face can be saved in silence. If I could think of something to say I'd tell Jack that **I shouldn't have done this to golf, I really shouldn't have, nor should I be thinking these things, much less writing all this down**. That even though *old age might be the best time to write a book about golf, as I'm now forced to write things down just for the sake of remembering them*, but that I've also become obsessed with counting, measuring, aiming and so forth, all self-centered activities as stated previously.

In any case I never saw Jack again. He dumped me after I didn't return his text message and then an email. He took it personally and disappeared.

money can be so happy
and unhappy

A commotion on the golf course last week, the first I've played since Jack kicked the can and left the world of golf.

Every round of golf is a hero's journey. We'd just started, four of us survivors, agreeing to a little game in which money would likely be exchanged, as there would be both winners and losers.

At the end of Hole 2, words are spoken in which all meaning is conveyed by pure sound. I couldn't hear the words clearly but knew them to be words I didn't want to hear—some sort of an accusation. I thought I heard the words, *You didn't finish the hole, dude*, and the accused saying he no longer wished to play the game though it had only just begun and that he, the new member of the group, the one accused, Jack's replacement, "**Never want to play with this group again**."

Then as quickly as the average golf swing begins and ends—if there is such a thing as an average golf swing—though even more suddenly, the accused picked up his golf bag and walked off the course without the three of us he'd had left behind, leaving before we'd given him a nickname, an occurrence without precedent.

The three of us left behind were stunned, as if struck by the force of a fierce 5-iron, but continued playing, walking to the tee at Hole #3 and teeing off there.

We spend the next four hours thinking, each of us individually and as a group, *What had I said? Why did he leave? Didn't he respect us? Had he always wanted to do something like this for which he'd be remembered?*

One of us says he'll never play with FD again (initials used to protect his anonymity); another says FD was going through a rough personal patch and consequently had a lot on his mind; another that FD is all about FD, and so on, until we reached the end of the 18th hole, shook hands and said goodbye to one another.

I said nothing the whole round time, not knowing what to say, after I'd tried to talk to FD immediately upon hearing what I heard as an accusation and then watching him walk away from me silently with his golf bag on his shoulder, knowing there was nothing I could say.

That night in bed, weighing whether I should call FD in the morning to see whether or not I had done anything that prompted him to leave the golf course or whether I should let his unilateral action speak for himself without my talking with him, I conclude that all I could offer him is a string of cliches.

What good would calling FD do? **Calling him would only make me feel better, that I had done the 'right thing'**, as I am not interested anymore in knowing his problems, knowing he's not interested in mine, already knowing his interests and values, that the things he considers important are of almost no importance to me and vice-versa. I spend too much time trying to get comfortable in my sleep, tossing then turning, twisting the night away, the image of which rolls off my tongue and into the hole-less hole of golf-related insomnia. Great things are expected of me—to be the patron saint of forgiveness, to measure up to the false belief that all golfers are my brothers and sisters, to go my own way whether or not anyone goes with me.

I decide not to call FD, finally fall asleep by counting the golf holes of the course I'm playing day after tomorrow.

37:—GOLDEN GATE BRIDGE SPANNING THE GOLDEN GATE, SAN FRANCISCO, CALIFORNIA

almost closing time for Schwitters

I'm still in the museum. It's close to closing time. Those who did or did not play golf in the rain finished two or three hours ago. I still can't imagine playing golf in the rain, for that matter I often can't imagine playing golf at all, but there's no end to it, this thinking about golf as if it's an actual way of being in the world.

A gradual fade-out is all I ask, a dimming of the lights by the attractive young museum guard who permits me, after hours, to come as close as I'd like to the Schwitters collage so as to almost touch it, nuzzle it if you will, so long as I don't pry it off the wall and take it home with me.

Giving Schwitters' collage a final look, now knowing something of the circumstances in which it was made but not quite able to come to terms with it, **I see the job of the artist is to make art after everything that's been understood about art has been made**.

1940. The Nazis invade Norway. Schwitters has just begun making a second *Merzbau* while living in Lysaker, a town near Oslo, abandoning the project upon the invasion as if knowing it would be destroyed anyway. Interned by Norwegian authorities, under the direction of the Nazis, at Vagan Folk High School in Kabelvag on the Lofoten Island, Schwitters

flees with his son and daughter-in-law on a Norwegian patrol vessel, to Leith, Scotland, one of the many birthplaces of golf. Officially classified as an 'enemy alien', he's moved between various internment camps in Scotland and England before being placed in a refugee camp on the Isle of Man, a collection of terraced houses around Hutchinson Square in the town of Douglas. Schwitters' new home soon became known as "the artist's camp" as so many of the detainees were artists, writers, professors, intellectuals. Kurt Schwitters is provided studio space, some materials, and makes a number of portraits for pay, also contributing to the camp newsletter, *The Camp*. Schwitters seems content, (he always seems content) having met an Englishwoman he comes to call *WantTe* because she asks him so frequently if he, 'Wants tea.'

Kurt Schwitters applies for release from the camp as early as October 1940, but is refused.

Episode 3

There's a last time you'll do this and a last time you'll do that, Jack's said once, among the last memorable things he said to me. *The world is full now of last things, much fuller of last things than at any time in human history. Golf too will come to an end,* Jack said.

I've come to the place, where I'm imagining more last times than ever, I said to Jack. *I'm also feeling the need of keeping ahead of them,* I said. *I'm afraid I've slipped far*

too often into the thought-patterns of a journalist, far too attached to measurements, evaluation of said measurements, interpretations, length of this and that, the accuracy and inaccuracy of my judgements.

You asked me once, Jack said, *WHO ARE YOU and I had no answer.* I'm asking you now, WHO ARE YOU? Are you a journalist, or are you writing a novel here? Or even worse, passing off what you've written as poetry? *This can't be poetry,* Jack says, *or if it is poetry you should have had the decency to take out all the adjectives and replace them with adverbs.*

Whose life did you say you were ruining? Could it have been mine? Jack said.

Episode 4

As far as golf is concerned I've come to the promised land where all I can do is dream that I'm hitting a golf ball, knowing it's my job to build a completely new swing from my imagination, I'd say to Jack were he still here.

Golf's the finest example of pretending something is important that is not, Jack would say if he was still here. *I overheard two grown men yesterday talking about their golf grips—interlocking or overlapping or ten-finger, and then the preferable fabric to wrap the grip, rubber, cordless or non-cordless, rubber or ribbed—for at least twenty minutes,*

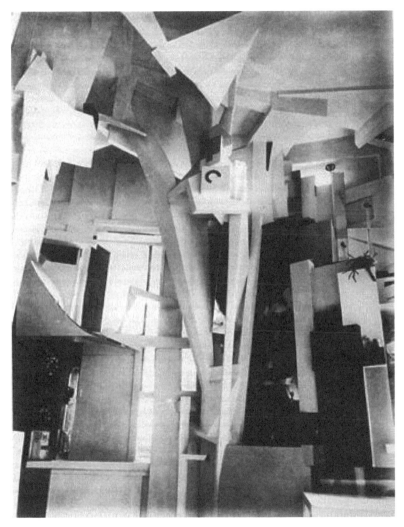

Kurt Schwitters, *Merzbau, 1923 - 1937*

I'm going to quit golf just before the last time I play, I can hear Jack say as if he was just here.

Kurt Schwitters was finally released from detention in November 1941, with the help of a man named Alexander Dorner of the Rhode Island School of Design. Schwitters moves to London, living in an attic flat with his future companion, the aforementioned Edith Thomas. Three years later Schwitters has a show of his work at The Modern Art Gallery—forty pieces of his art were displayed, but only one was sold.

Earlier that year Schwitters had been informed that his Merzbau in Hanover, his signature work of art, had been destroyed by Allied bombing. Living at this point in the Lake District of Britain, he began construction on a **Merzbarn** near Ambleside, home to the poets Wordsworth and Coleridge. The death mask which he'd made of his infant son is one of his only possessions.

On January 7, 1948 Kurt Schwitters is granted British citizenship, dying the following day of acute pulmonary myocarditis, whatever that may be.

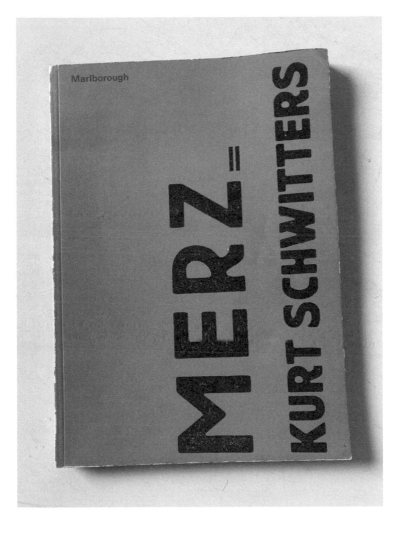

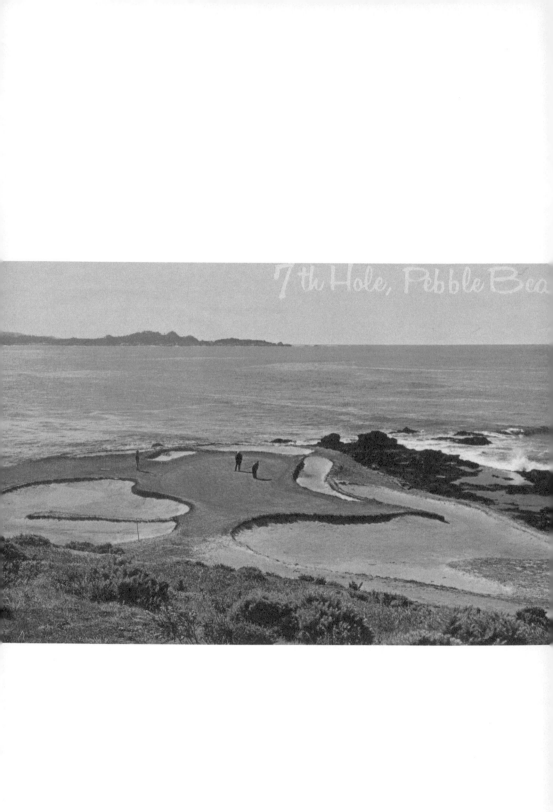

7th Hole, Pebble Bea

post mortem match

Episode 1

Yes, Jack passed on, he moved that far away, somewhere in the mountains. I heard he was living in Reno, the last place I thought I'd find him though he did love to gamble. What's he doing in Reno I wonder? Only Jack knows and, I assume, his new improved wife, a much younger woman said to be a stalker of white-tailed deer, born in a deep southern state where nothing good happens after midnight, Jack having left his old wife after she told him he had "to learn to love himself" if the marriage had any chance of surviving.

Episode 2

I drove to Reno not long ago inquiring as to Jack's whereabouts but came up empty, though I managed to acquire gushers of misinformation, both the 'raw' and the 'cooked' as the legendary anthropologist Levi-Strauss identified certain categorical opposites of native tribal behaviors. I've been told by both reliable public and private sources that there are some fine golf courses in Reno, but I didn't play one of them as my quest to track down Jack was paramount.

I *knew*—how much I've grown to doubt the words *I knew*, as well as its cognitive associates—that I wouldn't find Jack in Reno, and that if I did the discovery would be purely accidental. I simply couldn't take the reports of Jack's

disappearance seriously, that he had indeed left earth, coming to the conclusion that Jack's either still alive wherever he is or that he isn't, and that there's nothing that I can do now regarding his life or death.

I can hear Jack as if it was yesterday, only it wasn't yesterday or the day before yesterday, it was sometime before and after both of those times. We were talking about our inability to come to terms with human nature, ours and others of our acquaintance, in which we sometimes slipped *into subhuman nature* as we liked to call it.

We'd both just become aware that we'd leave no discernibly great legacy behind. *I'm happy that others have seen to it to leave their legacies behind,* Jack said, *taking all the pressure off us to do so.*

Jack also confided in me, not long before his departure, that he had seen one man in our golf group as a sheep and couldn't unsee him this way. *You can imagine who I'm speaking* of, Jack said of this man who was an accomplished follower, always picking up stray tee-times when one of our regulars dropped out but never offering to do for us what we'd done for him. Jack noted the yellowing of the eyes, the indecision in the voice, the hapless following of the leader even though the premise we operated on as a group offered a range of options as to the concept of leadership:

1) <u>that there was no leader;</u>

2) <u>that we were all leaders;</u>

 (or the third and much preferred option)

3) <u>*that the follower was the leader*</u> <u>(revolutionary post-modern parlance)</u>.

Jack believed, in either case, this man was now being punished for his lack of imagination and initiative and was turning into a sheep before our eyes. *He'll be an actual ungulate next time we see him*, Jack said, *it won't be long before he's braying*, or whatever sound it is that ungulates make.

At a certain age one begins to look like one's regrets, Jack said of this poor man, our friend, doomed to sheephood in Jack's mind.

In the meantime, I've painted the tips of my golf shoes cadmium yellow—one coat acrylic and one coat in oil—taking golf matters into my own hands. (I'd briefly considered painting the tips of my golf shoes blue, then reconsidered, the color blue not being strong enough, *as blue is a living-on-the-surface-of life kind of color*).

Frustrated with recent performances—my head moving over the golf ball time after time, no matter that my mind understands on both conscious and subliminal levels that nothing good can ever happen when the head lifts, the

consequence of which produces nothing but a series of topped golf balls, each worse than the other—<u>the yellow shoe tips are a visual reminder to keep my head down!</u>

I play around with my thinking now, I dabble in thought, scribble a few words now and then but only if they come out of nowhere. The voices I hear are mostly older voices, not only Jack's voice but others too. The voice of *Fallen Man* who I asked once about how he would answer if someone asked, **'What did you do with your life**'? saying, '**I guess I watched sports**." Original language, so rare that I'll never forget where I first heard it: on Hole 16 or 17 walking toward our next shots. And the beet farmer I met on the golf course in Cody, Wyoming who pulled a cell phone out of his bag on the 1st tee to call his friend to come play, saying, '**Get over here quick, let's smack the white**.' I'd never heard these words used before—*let's smack the white*—and asked if he'd heard the phrase somewhere? *No*, he said, *I made it up just now.* I didn't know this man, I'd just met him, yet I knew that anyone who could use language with that kind of freshness and spontaneity was a poet, and that a poet had once written, **One cannot always say a thing clearly and retain the poetry of what one is saying**.

In any case I've left Reno far behind and transferred all golf conversation from Jack to Hank. Hank and I captured the club championship this year, overcoming great obstacles on

the back nine to do so. One of us—it wasn't me—threw his hat high into the air, for he was jubilant, and soon we were jumping into one another's arms, our bodies dancing around in our golf clothes, making the sound of my washing machine during its high speed rinse cycle. We were so happy, so victorious! On my way home from the golf course I had the angel thought of giving the money I'd just won to charity, not that there was much, only a pittance and a championship trophy made of brightly colored plastic that Hank and I were supposed to share, but decided to split in half instead.

O well, it's only golf, I thought when I thought about Jack, or Hank for that matter, it's only golf whether we're together or apart, dead or alive. It's only golf, everything to us at the time, though golf seems increasingly like a period piece to me now, a sport of which we'll all say in the not too distant future, *"We played Golf? Really?"*

James Brown Statue, Augusta, Georgia

witness the summary:
the testimony of an exile

For your consideration, as if stated in a court of law, regarding my time in golf: Yes I cheated, but cheating brought no happiness so I gave it up. I killed a bird with a golf ball and over-thought the incident, creating a tragedy that's already been reported. If I should ever play golf with meaning and purpose again I'll still give myself putts, but not without first asking others in the group, *'Is that good'*? (to which at least one of them will say, *'Not bad.'*) I'll play an unmarked golf ball too, hoping to prove my integrity at the very least to myself.

By this time, more toward the end than the beginning, golf's become an activity I've committed to memory. When I play I mostly play alone. Playing alone I come to see is like eating alone, and I seem to have become one of those people who prefer to play golf while eating alone.

I play early in the morning, frequently on Thursday, Thursday not being a day of any special distinction, only the day the trash truck bellies up the street in front of my house thirty minutes before dawn and wakes me; or I play late in the evening of a long summer's day when there's little of my past or the so-called future to be discovered. Only the most solitary of golfers are out at these prelapsarian hours, and I have the golf course almost all to myself.

Playing golf alone—it doesn't really seem to matter what
time I play, though I'm beginning to prefer the evening
one week and morning the next—I often feel the ideal
walking with me, the very same ideal that won't permit me
to come to the place when I no longer feel the need to
be what I'll probably never be: a better golfer. Even at my
ever advancing age I'm still discovering things I need to
change with my golf swing and then, just as it has happened
in the past, 3, 4, or 5 swings later, renounce what I've just
discovered.

Episode 3

**The less I play the easier It is to see that playing golf by
myself is the solution to many self-imposed problems,
a kind of spiritual experience without long-winded
theological explanations of heaven and hell,** I discover I'm
a born-again pantheist, deeply feeling how the grass and the
trees and the wind love to perform on these cold mornings
and breezy evenings with or without me.

The wind is such a joker! Sometimes it takes my golf ball at
the moment of impact into the palm of its own hands and
throws it wherever it pleases. I'm consumed by its versatile
invisibility, the wind that is, which is to say I also hear Jack in
the void as it were, whispering for me to keep my head down
through impact and not stand too close the ball. Whatever I
feel or don't feel might be self-induced—at least it seems so
to me now that I'm both near the top of the mountain and
close to the very bottom, looking up at both the profound
climb I've made and the catastrophic fall I'm soon to take.

Golfing alone, I'm often walking through a gallery filled with the words and pictures of a past life in which I wander through a maze of poor golf shots, wasted opportunities for par, self-flagellations, never seeming to be able to make the change from doing what I'm doing to doing something better, something new, something I've never tried before. Instead of keeping score I scribble words on my scorecard: *the curse of perfection is protected in the architecture of the ideal*, whatever that may mean, having no idea, only that it meant something to me at the time of its writing.

I often lie in bed in the dark of not quite morning, having gotten through the night by permitting positive golf images to pour over me, remembering lines of poems I've already remembered.

I play acceptable golf when not yet awake, and even better golf in-between my waking and the sleep I can't get enough of, laying there in the half-light of dawn, having wadded up my insomnia into a small round trapezoid to be tossed casually over my left shoulder, re-setting the alarm clock for 6 am so I can get to the golf course in time to be first to tee-off.

Playing golf alone—I allow no ideas on the course—actual thinking is out of the equation. When I hit a bad shot, I put another ball down and hit it, usually for the better though sometimes for the worse and, if worse, I put down another ball and hit it once more, but with even greater emphasis. If I miss a putt I putt again. A poor tee-shot is given its proper descriptor—*pissing off the front porch*, as the front porch is a place so many of us remember so fondly, having said goodbye to our mothers and fathers from that cosy portal.

It's useless to think, as I sometimes think walking from hole-to hole, how much differently I might have used my time had I not been a golfer, remembering that when I first started playing seriously, with the intent of playing at least once a week, I couldn't wait to play. It's equally pointless to think I'll start doing everything I've put off doing once I get off the golf course; that is, to actualize my potential, one of the Greek ideals I seem to have lost sight of, my sight no longer what it once was, only able to see now 150 yards at most on a clear day.

Sometimes it appears golf has taken my ego away from me shot-by-shot, whittling it to near extinction. Did this happen overnight? Or was it lost to a gradual pile up of days and years which I no longer officially remember?

I'm now only able to recall a vague progression of tee-times moving steadily toward a dénouement not of my own making, made just as much by the ones watching me play golf when I'd asked them not to, carrying cellphones in their back pockets, invading my self-consciousness, the space I'd asked them politely to keep out of.

I walk with a slight limp now, a dystopian right knee 'issue' that also increases exponentially in my left hip, the result of the quantum physics of bodily decay, my swing now slowed to the feathery slash of an elder statesmen. My golf ball's no longer the shiny white it was when I began playing; it's almost lime green, the color of my favorite sweater, the one Jack gave me before he left town.

(And from time to time I take a break—a *sabbatical* as I like to call it —and give my unused golf hours away to others more needy.)

Playing alone this morning, my round begins par, par, par, an unexpected three pars in a row. This can't be correct, rather there's something very wrong, **this shouldn't be happening** as I like to say about a world that's gradually filling up with people I need to apologize to. A hole or two later, my good golf comes to an halt. I top two balls, skull three. It must be the hummus, I'm eating too much hummus, I'll cut down on the hummus and see what happens next time I play.

the genius of memory

Nothing's as easy as it looks, it's the most difficult thing in the world. We either rise to the occasion or sink a little further each time we try. I seem to prefer the sinking, it suits all two sides of me, though nothing will ever live up to the old standards of heaven and hell. Heaven has the lighter touch, but the time I've spent in hell stands out as the time I most remember; in hell I feel most alive. But is it really hell or only a simulation?

The joy, when there is joy, is front loaded toward the beginning when there's actually still time to get the bugs out. *I dawdled*, I once admitted to Jack, and drank and fornicated and made money accordingly, the usual course of a man's life whether in the city or its countrysides. Yes golf ruined my life, but what incredible delights along the way! And memories too, too numerous to mention! BJ, who calls himself 'worst golfer in the world', playing the back nine with only his putter. Hackin' Bob hitting balls on the range for 2 hours before his tee-time and then collapsing on the second hole from back pain, writhing on the ground like the upside-down insect we think he looks like, kicking his legs and flopping around on the tee-box. **O to to be in the presence of such genius, to feel that alive once again!**

This morning on Hole 13 of all places, my ball comes to rest in the abyss. There needs to be a ruling, as there is from time to time in any game of chance or skill: the abyss, as I've defined it, is either a place where the ball belongs or does not belong, this being one of the problems with man-made borders: **the question is, who gets to decide?**

It's this very morning, the morning in question, the one I now speak of, when I'm seized by a unexpectedly specific profundity while playing golf alone: **no one really knows anything, that all that can be known even by the most enlightened among us is a semblance of knowing,** a sly little pinprick that opens ever so slightly to point vaguely toward the path between cause and effect. This profundity, if that's what it is—and I'm not saying it is—felt so profound it had to be true in the privately thrilling way a suddenly revealed truth is true: that all that can be known, even by the most enlightened among us, and I don't count myself among the enlightened necessarily, is only some microscopic semblance of knowing, and not the eternal guiding light as once thought and believed.

It feels now like I'm zeroing in on the ending, the ending only I can create, in imitation of other endings of course and with trace amounts of imitation left over from the ending of

other golf and non-golf books *The truth of the matter is that I can only imitate myself, that imitating anyone other than myself is a crime* once one reaches a certain stage or age, nor could I ever properly imitate Hackin' Bob or rise to the level of creativity achieved by the legendary BJ who, after a miserable front 9, played the back 9 with only his putter.

When I hit the inevitable bad shot now I stamp my foot as delicately as possible so as not to disturb the food chain or dead poets, silently demanding to know what golf has given me other than a sore foot and a lower back filled with problematic vertebrae. I stay on the surface of things as long as possible.

I promise myself I'll retire, give all this nonsense up, share my money with the charity of my choosing, keep just enough to live on in the kind of reduced modesty I'm most comfortable with. I'll have a better time golfing if I do; enjoy my hand creams and foot massages, a tumbler or two of scotch every evening in front of a small woodless gas-lit fire that leaves no pile of ash, content with small things that are growing smaller, if no less lively, day-by-day. From now on I'll undertake only those things I'm good at.

Enough of the past, the past's never done a thing for me, it's too damm wet and soggy.

Just go to sleep for goodness sake, I tell myself, *stop replaying the holes in your head*. Dawn, ruthless creature that it is, will be here soon enough. I've promised myself I'll wake up early and play. I haven't given up on golf, I can't, I won't, though it feels as if golf's given up on me. I can only get to a certain limited position in my backswing now, a position just barely good enough to golf with.

I'm going to aim at the big white cloud and let it fly. *Yes, yes, yes,* I'll scream, truly believing I'm at least three-quarters toward discovering the secret of a better swing. *I've finally come to the place where all I can do is imagine hitting a golf ball*, knowing I must build my swing from the ground up, and that from this point forward the golf swing must come from my imagination. **There's still business to be done! I've digressed and then improved my digression.** Certainly I can improve from here, not scientifically but by keeping my sights as low as possible, acting as if I'm doing something important and thereby making a real ground-level commitment to the game.

And where am I when my enlightenment descends? On the golf course, walking off the green of the 13th hole.

Coda

Of course this ending won't do. It's bound to disappoint everyone involved, all who've gotten to this point, the golfer who reads and the golfer who'd rather look at pictures. I seem to have had a good life overall, despite the cliches, I've quit the game for the time being however, thinking I have to quit the game to better understand it. Maybe I'll play golf again and maybe I won't; everything's hanging in the balance and more will be revealed. I can say definitively the end is coming earlier these days, or later, depending on one's point of view.

Somewhere in this world there's a poem with the line—*if you look at anything long enough it turns to water*. I read the poem once and never forgot the line but now can't find the poem anywhere and so can't be sure it was in a poem at all or was only something I imagined reading. The line stuck with me however, as it applies to everything.

Afterward

Hello friends, I'm the Jack 'portrayed' in the book Brooks Roddan has written, "Golf is Ruining My Life." Though I quit playing golf a year or two before my alleged disappearance, Brooks asked me to write an afterword to the book he worked so diligently on for so many, long, dogged years, and I agreed, though I'm not much of a writer myself.

I knew Brooks well, having played perhaps three or four hundred rounds of golf with him over the years, and can say at the very least that he certainly has a unique perspective on the game. I read the book from the very end to the beginning, and then once again from the beginning to end, and found in both readings the book to be a credit to the game. I also think it's critical to note that **Brooks says *golf is ruining his life*, and not that golf has ruined his life**, for his life is as good as a life can be. And another thing of note: Brooks Roddan is not his real name, it's only a nickname—his real name is Thomas Fuller.

Bibliography
Texts and Influencers

Artaud, Antoine. "Van Gogh, The Man Suicided by Society." First published 1947, Editions Gallimard, Paris. Excerpted in Horizon, #97, January, 1947.

Famous Sidekicks—Don Quixote and Sancho Panza; Laurel and Hardy; Vladimir and Estragon; Lone Ranger and Tonto.

Carson, Rachel. *Silent Spring*. Houghton Mifflin. 1962.

Pliny the Elder, 24-79 A.D.—Roman naturalist and philosopher, wrote what would become the editorial model for encyclopedias, *Naturalis Historia*.

Heraclitus—6th C BCE, Ephesues, Anatolia (now Selcuk, Turkey.) Pre-Socratic, fire the basic stuff of the universe.

Lundqvist, Sven. *A History of Bombing*. New Press. 2001.
Lundqvist, Sven. *Exterminate All the Brutes*. New Press. 1992.

Jeffers, Robinson. *The Wild God of the World*: An Anthology. Stanford University Press. 2003.

Barkow, Al. *Getting to the Dancefloor: An Oral History of American Golf*. Atheuneum Books. 1988.

Roberts, Bernadette. *The Path to No Self*. State University of New York. 1985.

Werner Heisenberg (1901-1976). German physicist. "Space is blue and birds fly in it."

Bernhard, Thomas. *Old Masters: A Comedy* (translated by Ewald Osers.) University of Chicago Press. 1985.

Alister MacKenzie (1870-1934). Golf course architect.

Tolstoy, Leo. *What is Art?* Penguin Classics. Wentworth Press. 2019.

Hogan, Ben, with Herbert Warren Wind. *Five Lessons: The Modern Fundamentals of Golf*. A.S. Barnes and Company, 1957.

Porchia, Antonio. *Voices* (translated by W.S. Merwin.) A Big Table Book. 1969.

Yeats, William Butler. *The Collected Poems of W.B. Yeats* (edited by Richard J. Finneran.) The Macmillian Company. 1963.

Burroughs, William S. 'The Art of Fiction', *Paris Review*, issue 35, Fall 1965.

Liberal Humanism—a way of being in the world that neither blesses or condemns. A liberal humanist is a person who knows he or she can only speak for themselves, while acknowledging other people have just as much right to be heard as they do. To say that a person practices 'liberal humanism' is to give that person a great compliment.

Gamard, Elizabeth Burns. *Kurt Schwitters' Merzbau: The Cathedral of Erotic Misery*. Princeton Architectual Press, 2000.

Elderfield, John. *Kurt Schwitters*. Thames and Hudson. 1985.

Motherwell, Robert. *The Dada Painters and Poets: An Anthology*. Belknap Press. 1989.

Robb, Graham. *Unlocking Mallarme*. Yale University Press. 1966.

Stevens, Wallace. *The Necessary Angel*. Vintage. 1965.

Illustrations

All illustrations are from
Missing Links Press Archive Collection
San Francisco, California

Except for material by:
Kurt Schwitters, Geprüft (Inspected), 1940
stamp, string, envelope, and paint on paper; 6 1/2 x 4 1/2 in.
(16.51 x 11.43 cm) San Francisco Museum of Modern Art,
Helen Crocker Russell Memorial Fund purchase
© Kurt Schwitters / Artists Rights Society (ARS), New York / VG
Bild-Kunst Bonn, Germany

COLOPHON

Typography
Avenir, Garamond
Minion Pro

Paper
70 lb matte white

Printing & Binding
McNaughton & Gunn
Saline, Michigan

Design
Thomas Ingalls,
Laina Terpstra
Ingalls Design,
San Francisco, California